Lelooska The Traditional Art of the Mask

Carving a Transformation Mask

Text written with
and photography by
Douglas Congdon-Martin

Schiffer Publishing Ltd

77 Lower Valley Road, Atglen, PA 19310

**To James Aul Seawid III,
my late brother, teacher and friend,
and to all of the house of Seawid.**

Cover & formal gallery photographs by Ralph Norris

Printed in Hong Kong

ISBN: 0-7643-0028-8

Book Design by Audrey L. Whiteside

Library of Congress Cataloging-in-Publication Data

Lelooska, 1934-
 The traditional art of the mask: carving a transformation mask/Lelooska.
 p. cm.
 ISBN 0-7643-0028-8 (pbk.)
 1. Wood-carving. 2. Indian masks--Northwest,
Pacific. 3. Indian wood-carving--Northwest,
Pacific. I. Title.
TT199.7.L44 1996
731'.75'089970795--dc20 96-27004
 CIP

Published by Schiffer Publishing, Ltd.
77 Lower Valley Road
Atglen, PA 19310
Phone: 610-593-1777
Fax: 610-593-2002

Please write for a free catalog.
This book may be purchased from the publisher.
Please include $2.95 for shipping.
Try your bookstore first.

We are interested in hearing from authors
with book ideas on related subjects.

CONTENTS

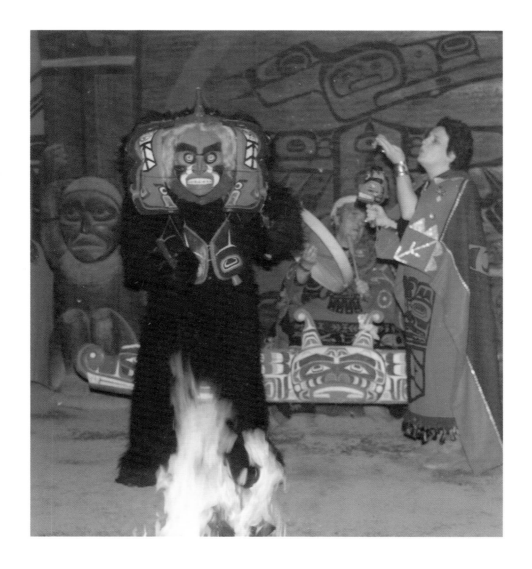

INTRODUCTION

The following was gleaned from several days of conversation between Lelooska and his editor Douglas Congdon-Martin. It is meant to help you understand the traditions behind the mask, the deep connections between Lelooska and the Kwakiutl people, and the place the mask has in the Kwakiutl culture.

Lelooska: This mask was used for telling one of the transformation stories. Most of the time the hero in a story like this is a nobleman, like the princess in the fairy tales.

In this story a man goes out and, just for fun, he shoots an eagle with his bow and arrow. The old eagle spirals down to the water, where he spreads his wings out and floats. The man gets stricken with guilt for having done such a frivolous, cruel thing, so he fishes the eagle out and very carefully removes the arrow from him. Then the eagle begins to speak to him in his language and tells him that what he did was a very bad thing. But since he did his best to mend the deed, he will have good luck rather than bad.

So the eagle told him that he would put a crystal in his shoulder. The eagle produced a small crystal placed the crystal in the shoulder of the young noble-man. The eagle told him that he would always have this to remember him by and would feel it when it comes on to rain. In the same way, when cold weather was coming, he would know because he would feel the crystal.

More than that, the eagle told him that if he did certain things, like bathing in cold sea water, rubbing himself all over with hemlock branches, or fasting during certain phases of the moon, he would gain supernatural power of a very, very high order. The young nobleman did as the eagle had said and became a very powerful shaman.

One day he was sitting out looking at the sea when he saw somebody walking on the beach. He was surprised because when he looked more carefully at this person he noticed that this person wasn't leaving any footprints in the sand. Eventually the figure walked right up to him, and she was a very beautiful young woman. He was a little nervous because of the fact that she did not leave any tracks. So she smiled at him and told him that she had been sent to be his wife. With that, she spread out her blanket and changed herself into a big eagle, and then changed herself back again.

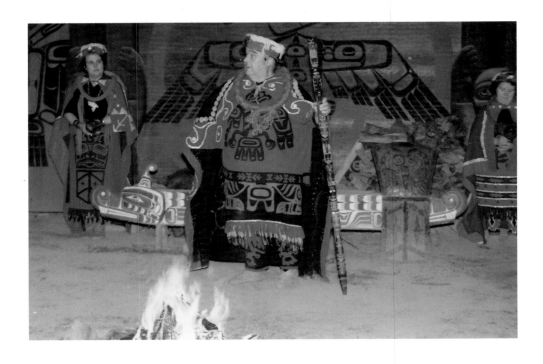

She said to him, "Now you know who my father is. My father is the chief of the eagles that you met a long time ago. He helped you to gain power, strength, and knowledge. Now, because he is well-pleased, he gives me to you in marriage, and our children will become rich and powerful. They will be great warriors, trappers, traders, and fishermen. They will be known all up and down the coast. They will be born to speak all of the languages of all of the tribes."

This all came to pass and it was from these children that this particular clan kept the eagle as an ancestor. That's why they are respected. Usually it is a clan genesis story when you are dealing with opening masks. In this mask the eagle transforms and you see the eagle's true self within the mask.

Of course the young nobleman wouldn't have done so well today. They would have thrown him in the calaboose for shooting an eagle. But that is basically the story. Not terribly exciting or interesting, but it left an interesting point. Nowadays we've got people using crystals for lots of things. From long, long ago the northwest coast people, at least the Kwakiutl and the Bella Coolas, have held that stones are very, very important. They are living entities. They live in certain caves on the Bella Coola River and if they are taken

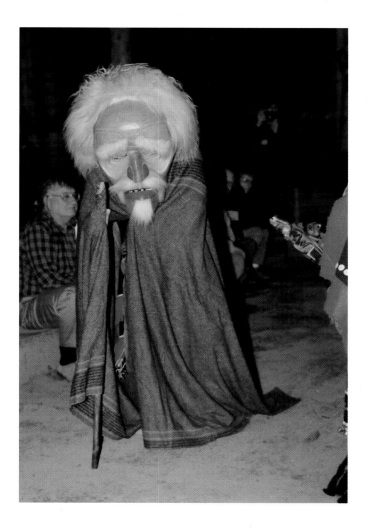

out, fed, and kept alive while they make you wealthy, strong, powerful, and provide all things desired.

DLCM: But you have to care for the crystals?

Lelooska: Oh, you have to care for them or the crystals die; if they die they have no use to you and will probably bring bad luck.

DLCM: What's involved in the care?

Lelooska: You cut your finger and rub a little blood on them once in a while. You wrap them in red cedar

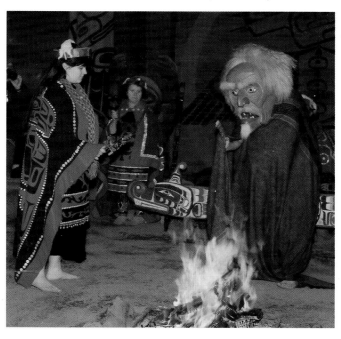

and when the moon changes then you unwrap them. The red cedar is a species and its bark is shredded and dyed red with the juice of the alder tree. That's what they use for the ceremony....dyed cedar bark. So by your blood and the power of the red cedar bark and certain incantations and songs you could keep the crystals healthy and happy.

Bella Coolas talk about the crystal cave and people go there. It's a very dangerous place to go, very hard to climb. And in the cave you could hear the crystals humming; they make a humming sound. One would sit there, fast, and think upon the crystals and look at them and listen to them. Finally, he would be able to understand which crystal would be the one that he could take.

I have crystals from long, long ago. I have a sea monster mask that has a crystal set into the forehead of the carving.

DLCM: What was the place of the mask carver in the community?

Lelooska: Well, in a lot of tribes, to be a carver you had to be born into a family that had the privilege of carving. Not everybody had the talent to be a carver, but people would come to one who was looked upon as a hereditary carver and they would speak to him about work they wanted done. And he would go to a

skilled slave, usually, trained as a carver who had no status or name and he would tell him how he wanted the work done. And the surrogate would do the carving. If it was something big and important, like a totem pole, the hereditary gave very careful supervision, but he was always around and overseeing.

DLCM: It's like the Italian model of the sculpting master, isn't it?

Lelooska: A little bit, yes. I hadn't thought about that. Another tribe said it's usually somebody that has the leisure time and is connected with the nobility that carves.

DLCM: A family connection?

Lelooska: In a way. It's sort of like being connected, in our society. It helps a lot. So, it worked the same way for some of these carvers.

DLCM: You gained the privilege of carving this mask through your friend, your brother...?

Lelooska: Yes. Through Chief James Sewid, my Kwakiutl brother. He's the one that gave the social and spiritual blessing to what I was doing.

DLCM: Were you carving this style before you met Jimmy?

Lelooska: I was experimenting and learning all I could. That's how I came to meet him in the first place. I was up there with a rep from the Indian Arts and Crafts Board and he had known Jimmy when he had been an anthropology student. When I met Jimmy it was just like coming home...the whole family, Jimmy and everyone. I brought some pictures of my work - it was back in the Kennedy-era when there was lots of money for the arts. It was just a really nice meeting. He was so forthcoming with information and encouragement, it was just like someone I had known all my life.

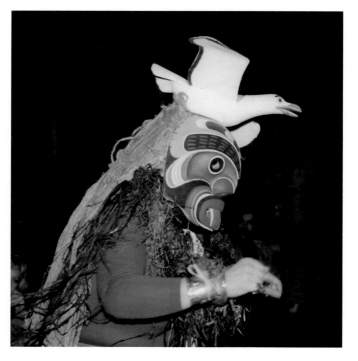

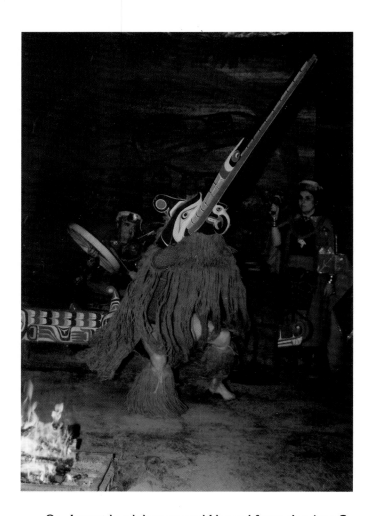

So, I went back home and I heard from the Arts & Crafts Board; Jimmy didn't have my phone number. Jimmy had called them and wanted them to tell me that he was coming down to visit me. He came down; it was the first time he had been out of Canada in his life. He came to commission me, the old way, as the person who would carve a mask of Kwe-kwis. The Kwe-kwis is the eagle of the undersea world. The creatures of the land have mythical counterparts beneath the sea. It's a layered creation, I guess. So he came down and described the mask and all the details and the story behind it, everything. The mask was to celebrate Jimmy's 40th anniversary.

So we made the mask, my brother, Smitty, and I. I learned as much about the masks and their traditions as the books could give me. I knew we had to sneak it into the house; other certain things had to be done, you know, so it wouldn't be seen, until it was going to be shown for the first time, the big event.

All these wonderful characters, the old people, the elders, came in to see the mask. They were all relatives, on one level or another. So, the big night came and Smitty showed them how to use the mask. He had done many school demonstrations and things like that, and was pretty good at handling complex masks. That night an audience of 700-800, Kwakiutl people from Bella Bella clear down to Comox, were repre-

sented. This showed the great respect in which Jimmy was held, because at that time he was serving as the Chief Counsellor for the tribe.

Smitty started in. I could see his feet, but the attendants had blankets up all around him. He came straight towards the fire. You travel sun-wise, always. To go the other way is about the dumbest thing that can be imagined. And he headed right straight for the fire. Just as I was about to run for my life, he made the prettiest turn and old Herbert Martin kind of took him in hand. He took him around the house as an attendant with a rattle. He got him out and I couldn't believe it. Absolutely couldn't believe it. The family was all delighted...they about patted Smitty to death when they got him behind the screen.

DLCM: When I came to a performance, the dances were performed one after another. Is that the way it would normally happen?

Lelooska: Well, it would depend on the particular performance.

DLCM: Are the performances more like a drama or more like a religious ceremony?

Lelooska: Really they are a melding of the two. They are dramatic. They had sacred aspects, but they also had pride, inheritance, and nobility involved. There were certain performances that were secular and there were the sacred dances. The sacred dances belonged to the Tseka. That's the sacred weather dance season. This is usually from November into January. This was a leisure time when the abundance and goods were laid in, so it was a good time for leisure and religious practices.

The non-sacred dances belong to the Bakoose. The Bakoose is the ordinary season of the year, which is usually either just before the salmon run or just after. It differs from group to group.

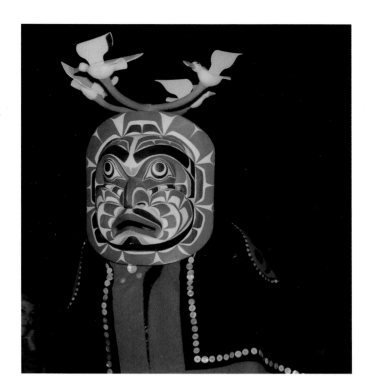

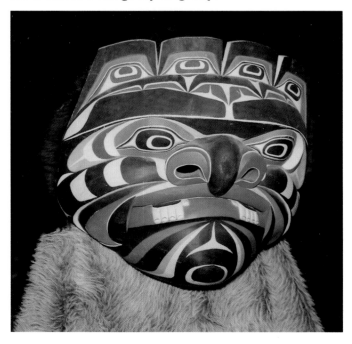

DLCM: Let's go back to the word belong. Did the season have a personality that owned the dance?

Lelooska: No, it simply means that it is the season for it. The Bakoose have a lot to do with the privileges of chiefs and some of it has to do hereditary privileges. It is a much lighter, happier time than the winter dance, which had very strict rules. In the old times they were never done in the same time or in the same season. The Tlasila are the non-sacred dances. While they are often comic and lighthearted, they involve a great deal of planning and are quite demanding on the dancers. This mask would be used in the klasila. It all changed, which is a little sad, and now they have the whole thing in one evening rather than taking a month as it used to. I should say it is one long, long evening.

DLCM: Was Jimmy himself a carver?

Lelooska: He was meant to be a carver and old Willy Seaweed was his uncle. But Jimmy wanted an education, he wanted to learn to read and write and felt he could do more for his people that way. That was pretty grown-up thinking for a kid. So after one trip to the coal seams up at Fort Rupert, which is where the got the material for the black paint, why, Jimmy took off. He ran away to Alert Bay where he lived with his grandmother, Lucy. She had a little house right on the tide-line practically. He fished and she picked berries and made baskets and they got along fine. And the uncles decided they wouldn't make a fuss, that they would sort of ignore the whole thing. Willy Seaweed was very disappointed indeed. But he forgave Jimmy eventually.

DLCM: Did you know Willy Seaweed?

Lelooska: Just briefly before he died. They pronounce it "Seaweed," but Jimmy said, "Sewid." Actually the proper way of saying it is "Seeweedee," and that means someone who is paddled towards. That means that the people come to him for advice and potlatches.

DLCM: That was Jimmy's family name.

Lelooska: Yes. His grandfather was Aul Sewid. A lot of people have that Sewid name by reason of the fact that they belong to one of the clans where he's prominent and the traditional story of their beginning. Aul Sewid gave a big potlatch and went before all the people and said that he was adding to his name "Aul." "Aul" means "the real" or "the legitimate". So he was Aul Sewid, "the real" Sewid. They had a choice at that point. They could try to squelch him by breaking a copper against him or giving a big potlatch and outdoing him. They showed their respect by accepting it.

DLCM: Was he any relation to Jimmy?

Lelooska: He was Jimmy's grandfather. Jimmy's father was killed by a falling tree, almost at the time he was born. The uncles were concerned that someone try to lay a claim to his privileges and positions, so they took little baby Jimmy down to center of the fishing village of Alert Bay. They called the people all together and they laid him down on a copper which is the symbol of wealth and put the chief's mask over his face. Then the uncles gave a speech in which they said we will defend him until he can defend himself. By that they were letting everyone know that they were going to see Jimmy have everything that he should have as his inheritance. The uncles had tremendous say where little Jimmy was concerned.

Many of the Kwakiutl and other tribes of the North-west never accepted the government's right to tell them that they couldn't potlatch and continue their traditional ceremonies. They couldn't bring themselves to submit to the Mamitla, that's what they call white people. It means "drifters."

DLCM: What is the root of that name?

Lelooska: When the tribes first met the white men, they were coming in ships with masts, sails, and trade goods, so they thought that these strange people that were coming to them were just drifting on the ocean and had no land of their own. So they called them drifters. Of course, they also made the assertion that these people were always cold, because they would trade wonderful things for sea otter skins, beaver pelts, land otter, martens, and mink. Skins were what they wanted more than anything else. And of course iron knives and things were hard to come by. Indeed any metal was highly prized. So here these foolish drifting souls gave these valuable goods away for skins, so it must be they're cold. And they also decided that there were no women among these drifters. The Kwakiutl concluded that these drifters, these first white people, had really never seen any women. Because they were so excited and wanted so badly to get hold of the women in the village they knew that there had to be something strange there. This just shows you how people come to conclusions that lead to prejudice.

DLCM: The masks were taken away from the Indians? How did that happen?

Lelooska: It started in the 1920s. The Indian Act actually came into being in the 1880s. But the villages were scattered and transportation was hard. Navigation was dangerous with the equipment they had at that time. So the authorities could only tell them

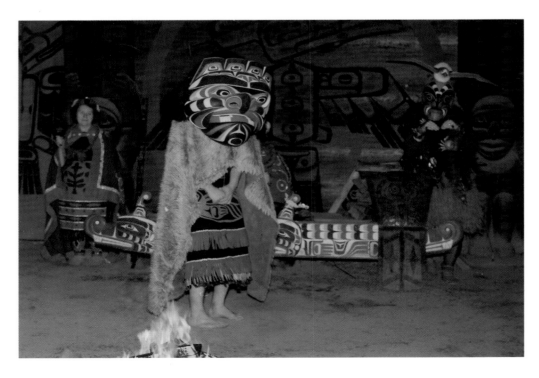

they weren't supposed to do it, and that was about all. The Indians would just go up into those villages in the great fjord places, like Kingcome Inlet, and have their potlatches and white law couldn't touch them.

Later on the government officials had gas boats and all kinds of good communication. There were lots of Mounties in the country at that time. The Provincial Police were organized. But it was the missionaries who were really the ones who put the pressure on for the enforcement of the law.

The English thought they would have to turn these wild, sea-faring, strange people into farmers. The English looked upon farming as being the destiny of the good, common Christian. They failed to see that all of these people were fishermen and that there was no land there that you could really farm on. So, everything they had to say about changing their way of life was utterly ridiculous. It just wouldn't work in their situation. There was a language barrier, and lots and lots of problems.

Nevertheless, as they got transportation and communication, they began to break up potlatches. They broke up one of the really big ones, and they arrested everybody that participated. Even the stool pigeon that wrote down all of the names for them so they could be arrested and packed off to trial. He ended up going to the state prison, with all of those "bad potlatching Indians."

DLCM: When they raided the potlatch did they confiscate the masks?

Lelooska: They confiscated many of the masks and ceremonial regalia. Yes. They took them to the church and put them on display and took pictures. They told how they were "missionizing these barbar-ians." And then they just sent the ceremonial treasures, barge loads of it, button blankets, copper, masks, things that would be worth millions now on the art market, to Victoria as evidence. The pride and wealth of a people was all tossed into a big barge, and the nobility was sent to prison. Some of them were there a few months, and some were there a couple of years. The ones that received the light sentences and got paroles were the ones that would give up their masks and regalia to the government, and to end these "horrendously evil ways." The stubborn ones got more time.

It all ended up the same way. Everything was shipped off to Ottawa, parceled out to museums and collectors. It was scattered across the world. It is possible to trace exactly how they got there and into that collection. A lot of the countries are repatriating, you know, what amounts to the wealth of the people's culture. And some of it has been returned. They got quite a bit back from the museum in Ottawa. And Jimmy had a lot to do with that. He discovered that it was crated up in storage in the basement of the big museum there. He offered to buy it right out of hand, which he could have done. He was extremely wealthy at that time, through fishing, investments, and things like that. They couldn't do that so he went back and talked to some of the chiefs, and they went back and took on the government. They had a lot of generously donated legal advice. And, finally, the government knuckled. And they said that they would send it back.

Then they had another problem because of the time from when Jimmy was a boy until he was a man, many people had died. It was a time when influenza, tuberculosis, all kinds of sicknesses were just destroy-

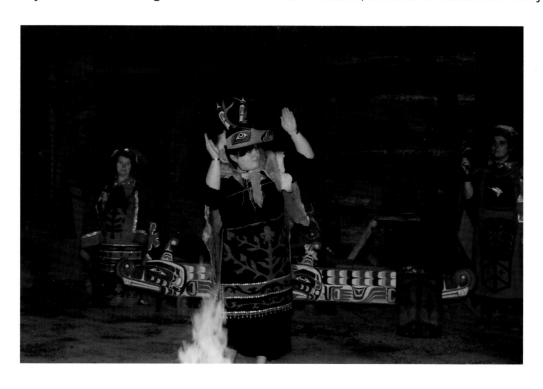

ing the population. They went from 10,000, in the Hudson's Bay Company survey, down to probably about 900 at the lowest point. Because of this, Jimmy realized that it couldn't go back to the individuals because there would be all kinds of fighting, quarreling, disharmony. So it should be put into a museum on Kwakiutl land and it would be there for the benefit of the young people so they could be proud of their culture. It would be there for the white people so they could realize that there was worth, beauty, and the tradition behind all these things. There was no league with the devil, or anything like that.

A number of pieces were returned. They had to split it into two groups because those in Fort Rupert wanted it there, and the only way they could get this dispute settled was to divide it and make two museums. They had a potlatch when they opened the museum on Quadro Island.

So things began to come in, and they're still coming in. Even a nice collection from Australia. That's a long trip, isn't it?

DLCM: From what you said it seems like the masks belonged to individuals.

Lelooska: Well, the mask is held in kind of a trust by the chief, the head of the lineage, and he has a lot of say over it. But actually the masks and all that are for the descendants of the marriages for the oncoming generations. The idea of just selling them out of hand was something the curio people and collectors kind of hoisted on them. So some things that hadn't been stolen by the government were getting sold and lost too. So the museum came at a good time.

DLCM: Have you trained any carvers among the Kwakiutl people?

Lelooska: I try to help them, but it's hard really, not living up there and just doing it on the weekend. We've had some carvers here. We even had Nathen Jackson, who was here for quite a while. He's probably the premier totem pole carver in Alaska.

DLCM: I presume that at some point the ban against potlatches was lifted?

Lelooska: Yes, in the early 1950s. None of it ever made any sense. It was just, you know, missionary zeal and politics and a lot of other things.

DLCM: Were they able to recover it after that? Were they practicing in secret around then?

Lelooska: They were doing a lot of things in secret. Some of them gave up completely and got involved in the church. Well, Jimmy was a leader. He joined the Anglican church and became a lay leader. He became an Anglican and a fully initiated Ha-Mat-Sa. He had the most beautiful balance between two cultures. He took the best, I think, of both and built a life. And he felt that's what everybody was going to have to do. Times were changing so much.

Rebuilding their pride was one thing he really wanted to do. So Jimmy did all that he could to encourage the revival of traditional arts and ceremonies. Jummy's passing was a terrible loss, a leader of strength and honor. I owe so much to this great man and his wonderful family. We all do.

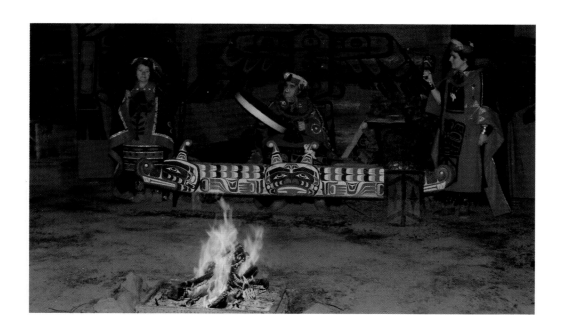

THE INNER MASK

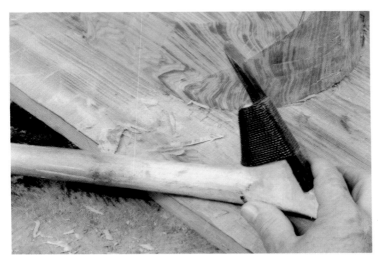

The adze is a plane blade attached to a handle cut from the branching point of a branch. It is bound with cordage covered with glue. I have a variety of sizes, some of them with curved blades.

To touch up the edge, I hone it with some 150 grit wet or dry paper wrapped around a piece of wood. Do the top of the edge...

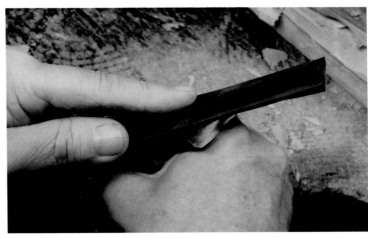

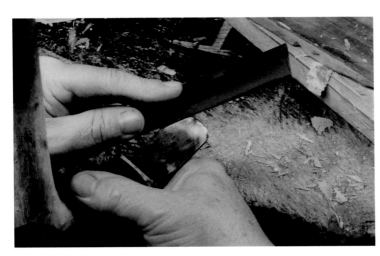

and the bottom.

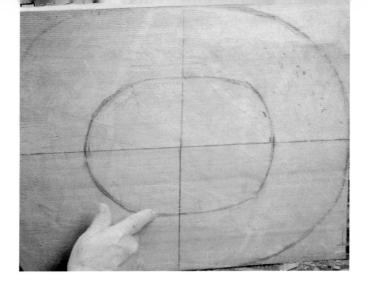

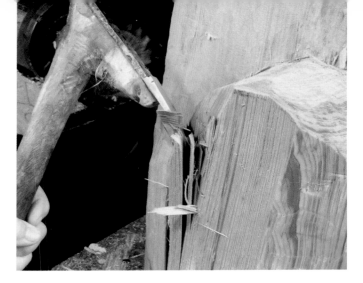

Knock off the edges of the face.

I carve my masks from moist red cedar. Living in the Northwest I am able to get old timber large enough to carve a mask from without joining. Depending on availability, you may need to join two or more pieces of wood to get the dimensions you need. For the inner mask, the wood needs to be 24" x 16" and 10" thick. Square the board up and mark it like this top and bottom. This gives bearings that I can return to for reference.

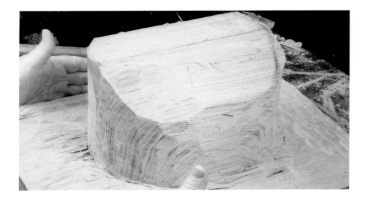

Removed to leave an apron 1 inch thick and around a mound in the center that is 12" long x 8" wide x 10" thick.

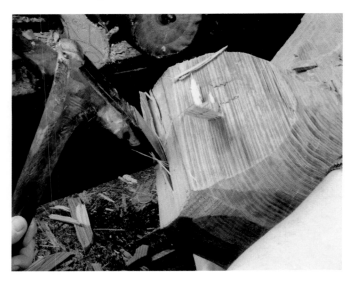

Continue to deepen the bevel of the edges...

The red cedar cleaves well so that it comes off in large chips.

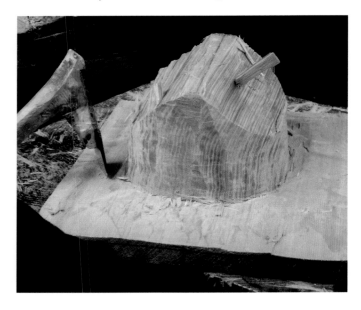

until you create a ridge along the center line. This creates a shape reminiscent of a house.

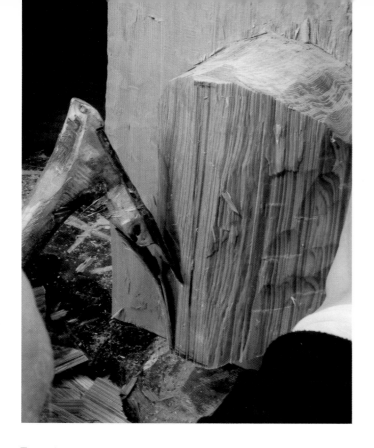

From there continue to round the face area.

and bevel the forehead from the ridge.

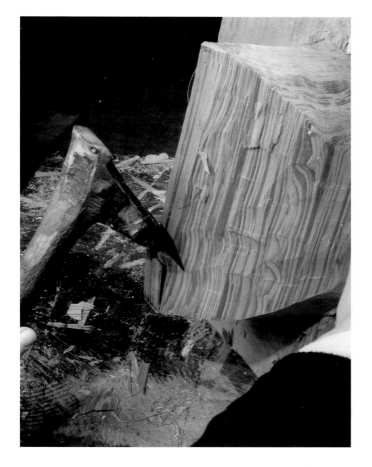

Hold the wood so the top of the mask is against the cutting block...

Turn the piece over and cut the chin slope in a similar way.

Carve each side of both the chin and forehead facets.

The chin is on the left. As you can see it is not as deep as the forehead. The facet cuts like this help keep the mask in proportion. They are easy to see and allow the carver to keep the angles correct.

The result. You now have three facets across the forehead and three across the chin.

The lines at the side of the forehead and chin facets are the centers of the next facets. If you keep them pretty much the same size and angle on each side, you will be taking off the same amount. Again this helps keep symmetry.

Create another facet along the bottom edge of the forehead, and carry it around the side, rounding the face.

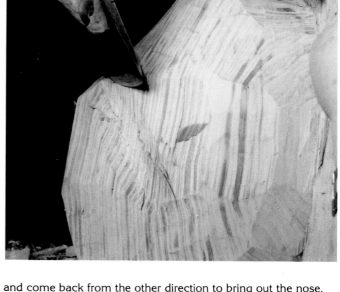

Round the forehead. This is a good time to check for symmetry and make any adjustments.

and come back from the other direction to bring out the nose.

Round the top of the head. At this point, instead of looking at the facets, I begin looking at the curves and how smoothly and evenly they flow.

Repeat on the other side.

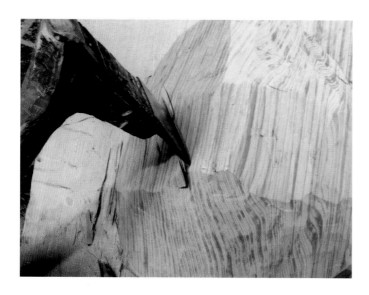

Cut along the side of the nose...

Blend the cheek surface back into the cut.

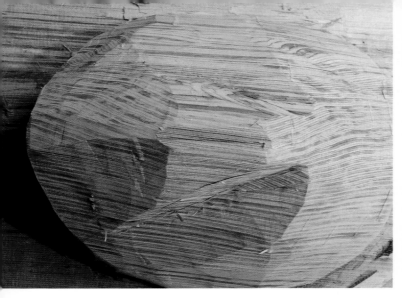 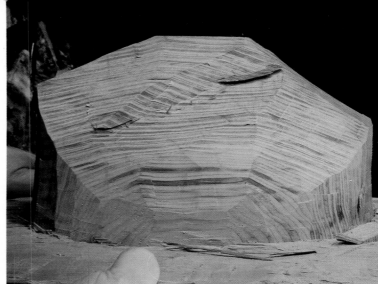

Progress. The facets, again, help me check for balance and symmetry.

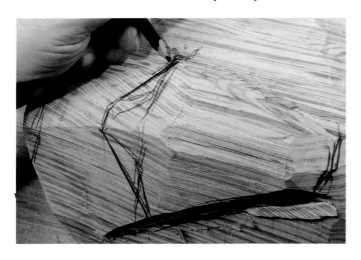

Draw in the beak.

Cut in below the point of the beak.

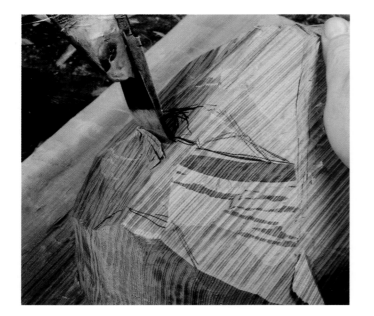

Reduce the wood beneath the beak.

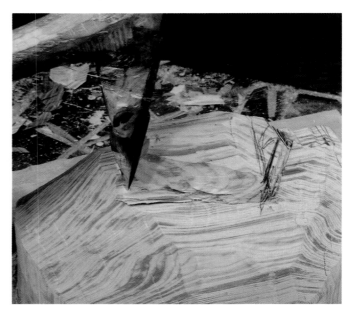

Cut the top of the beak back to the forehead.

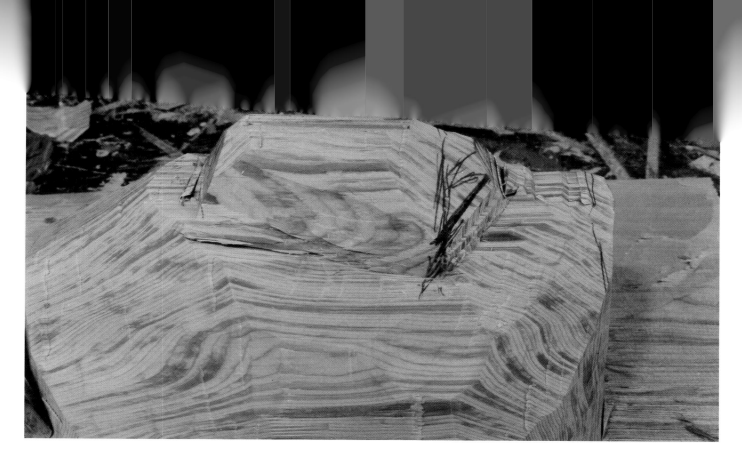

Progress.

I need to round off the forehead and pull it back to allow clearance for the external parts of the mask.

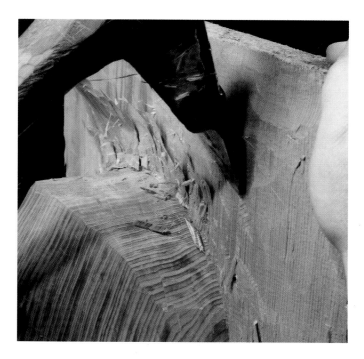

As I work the face I reduce the surrounding board. Gradually I want to create a board of uniform thickness.

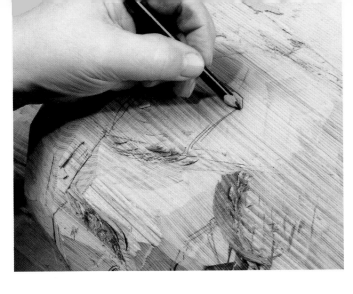

To give contour to the bridge of the nose I use a smaller adze with a curved blade.

When the beak is roughed in, I draw the eye areas...

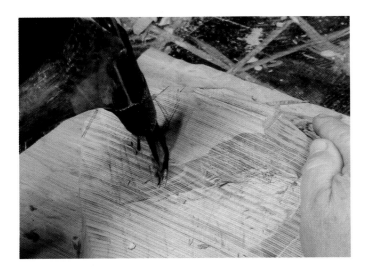

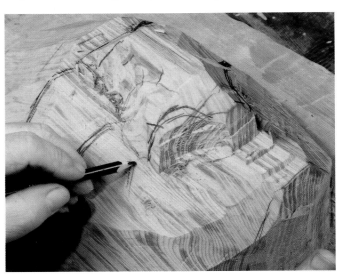

I continue with the same tool at the bottom edge of the beak. This allows me to cut a curve.

and the details of the nose and mouth. As the wood is removed, these will be redrawn throughout the carving.

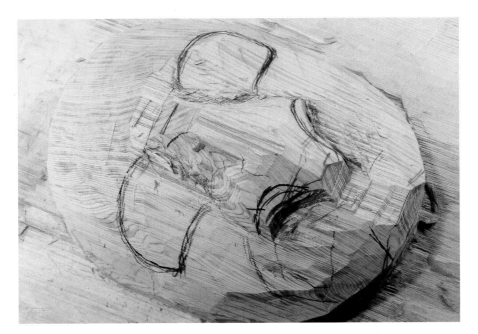

Progress.

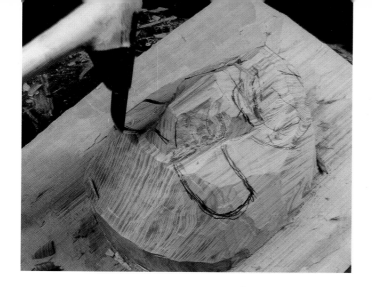

Continue to shape the forehead.

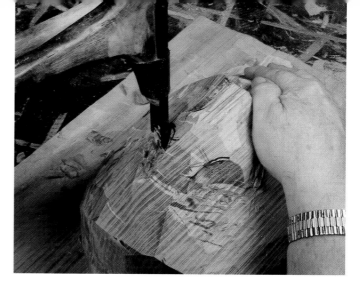

and carve the strong curves at the lower edge of the beak.

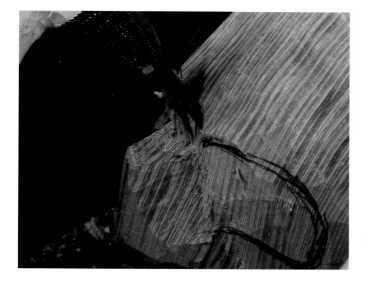

Reduce the top of the nose, bringing it down between the eyes.

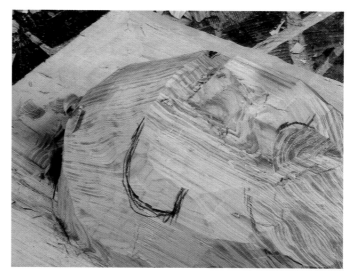

I have increased the slope of the forehead.

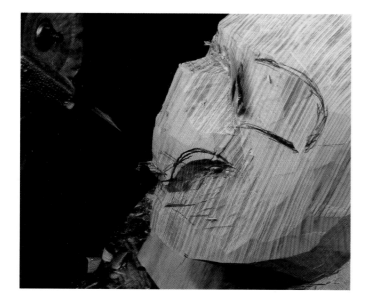

Round the bottom of the beak back to the face...

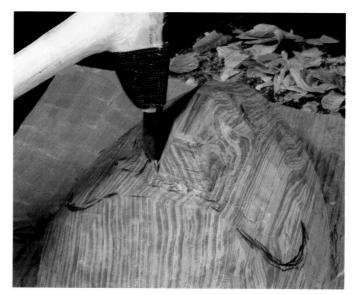

The beak is then shaped, coming to a ridge at the front and rounding at the sides.

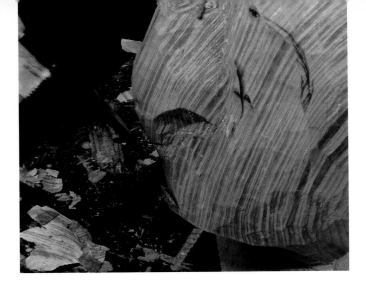

The slope of the chin is increased.

Use the crooked knife to smooth the carving and create the contours.

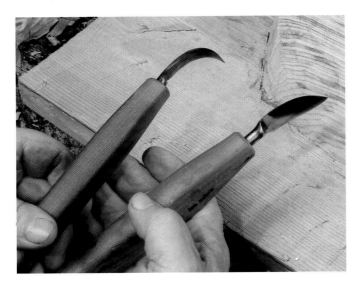

These are crooked knives. They can do the work of a knife or a gouge. Similar knives are found among native carvers throughout the northern hemisphere. The Ojibwa call it "mikatogin," while the Hudson Bay Company called them canoe knives.

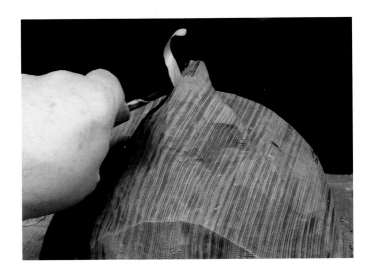

Check for balance and make adjustments as you go. Here I am looking up the nose and trimming one edge.

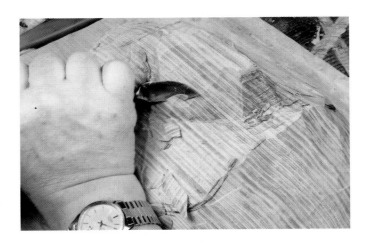

With a two-handed grip you can either pull or push. They work either with or across the grain. Here on the beak I am using it for hollowing.

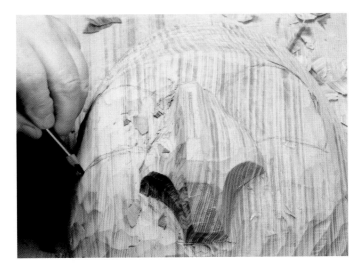

Redraw the eyes...

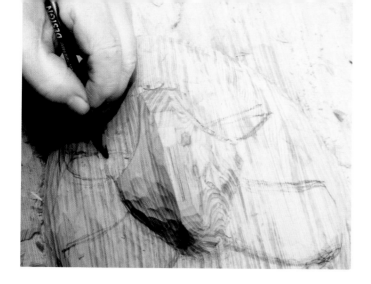

and the mouth.

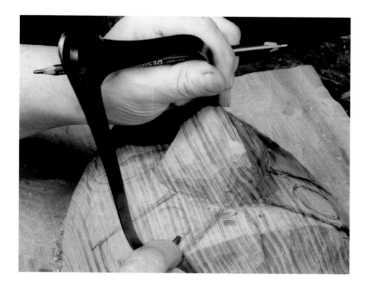

A caliper helps me be sure that the eyes are in the same position on each side. Calipers were available very early to the Kwakiutl, through trading with the English.

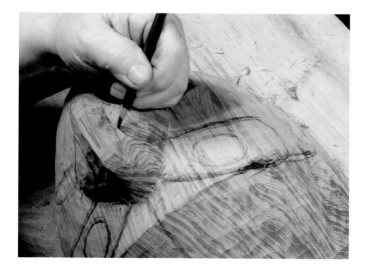

Continue with the details of the beak, again using the caliper to make sure things are even.

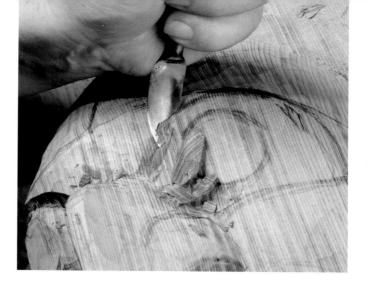

The area surrounding the eye center is carved by cutting in from the outer line at a fairly steep angle...

and coming back from the center at a shallower angle.

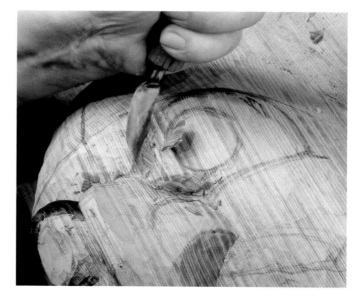

Clean up the cut. The object is to relieve the wood between the eye center and the outer design.

Continue around the back of the eye. Again, the cut is nearly straight down at the line, and slopes back from the center. At the back, where there is more distance, that slope is longer. First cut on the line...

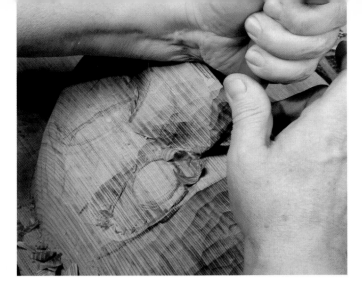

With the basic shape defined, deepen the curve around the inside of the eye...

then carve back to it to relieve it, making a v-cut.

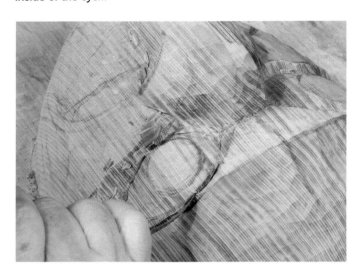

and at the top. Cut in on the line...

With the initial v-cut established, slope the surface from the eye center back to it.

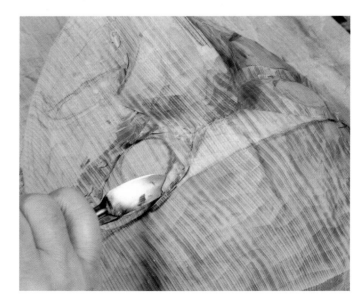

and back from the center.

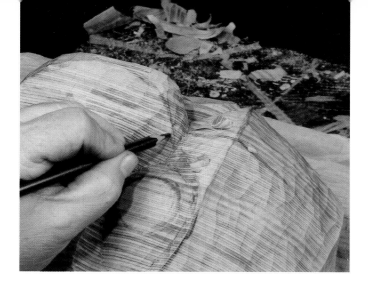

Define the curve of the top of the nose.

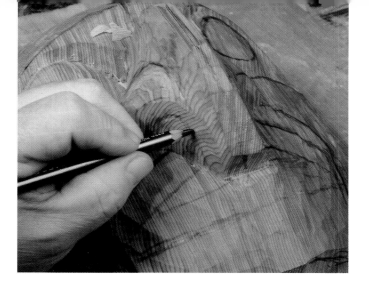

Draw the line of the nostril opening.

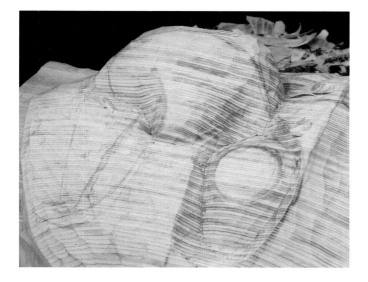

and the bottom.

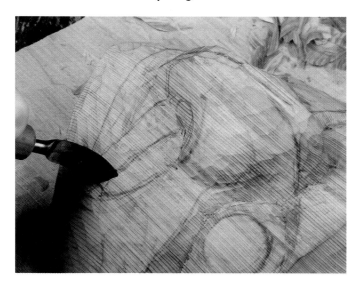

Cut along the top line of the upper lip angling the down toward the cheek line. Go over the cut two or three times to make it deeper.

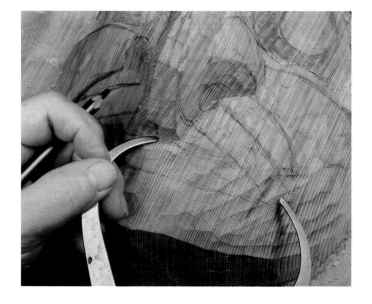

Draw in the mouth, using the caliper to insure balance and symmetry.

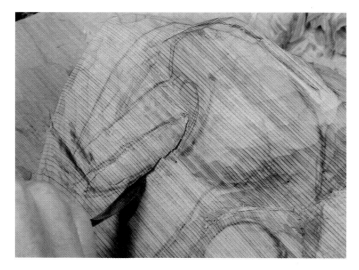

Cut along the cheek line at an angle that will meet the lip cut.

23

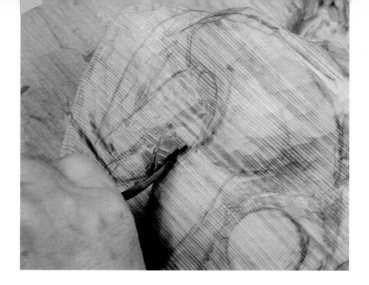

Again, deepen the cut by repeating it.

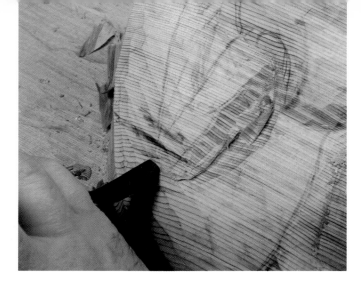

Continue the line down the side of the mouth to the chin.

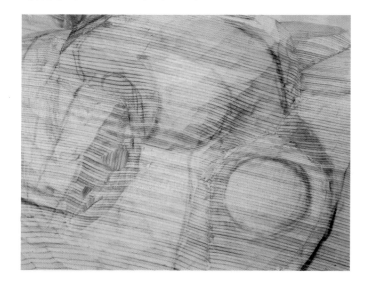

Repeat the process until a channel is cut between the upper lip and the cheek line. This will remain angular.

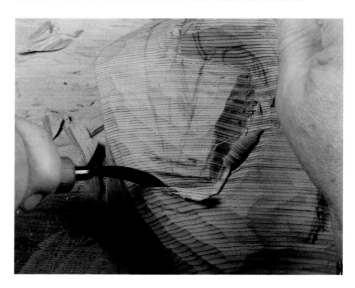

Relieve the line from the other side.

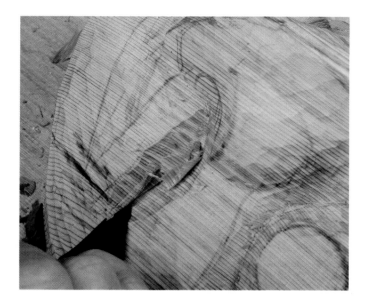

Clean up the channel.

Refine the curve..

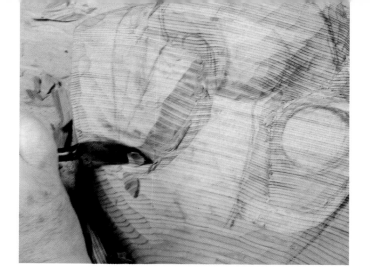

and soften the corner of the mouth.

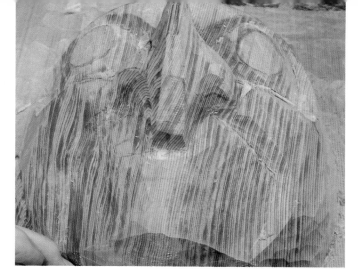

Check for balance and adjust.

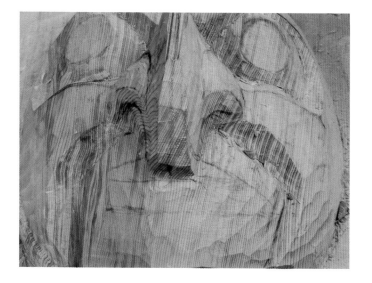

Repeat on the other side for this result.

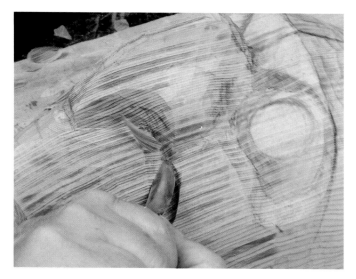

Remember, the facets of the carving give you the best view of the symmetry. Here beside the nose I have established facets that are balanced, so I can go ahead and round things off.

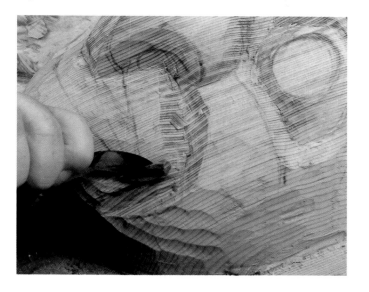

Round over the mouth mound into the groove. A lot of character comes from the mouth, so I spend some time getting it right.

Curve the cheek back at the nose.

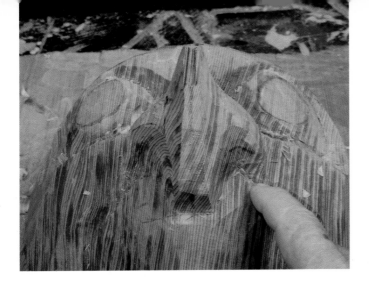

The curve on one side of the nose is greater than the other...

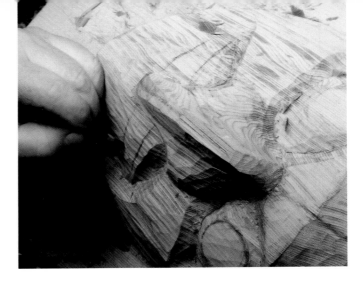

Continue with the bottom edge of the upper lip...

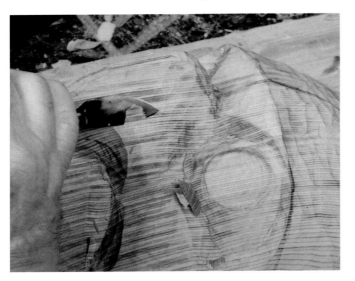

so I adjust the thicker side.

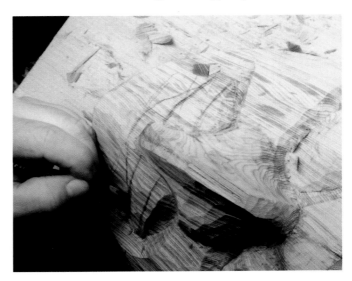

and the top of the bottom lip. The opening is important because it is often used by the wearer to see through.

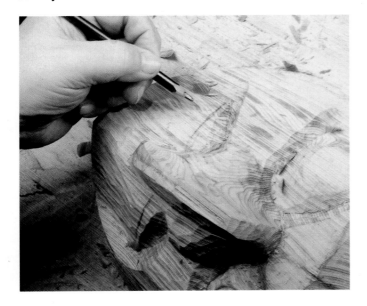

Smooth the mouth area and draw the mouth. Begin with the top line of the upper lip.

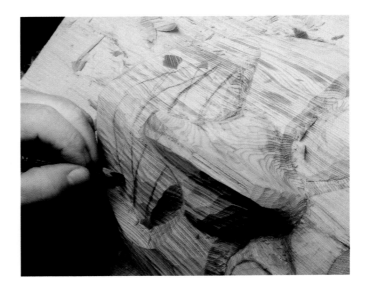

Finally draw the bottom line of the lower lip.

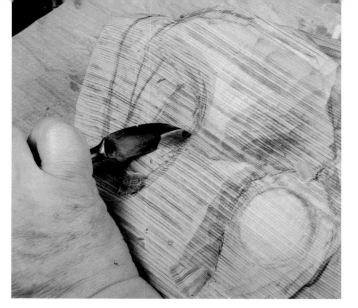

Shape the area above the upper lip.

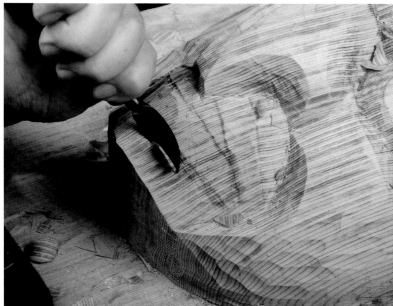

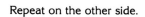

Shape the area under the lower lip, given a concave flow.

Repeat on the other side.

Progress.

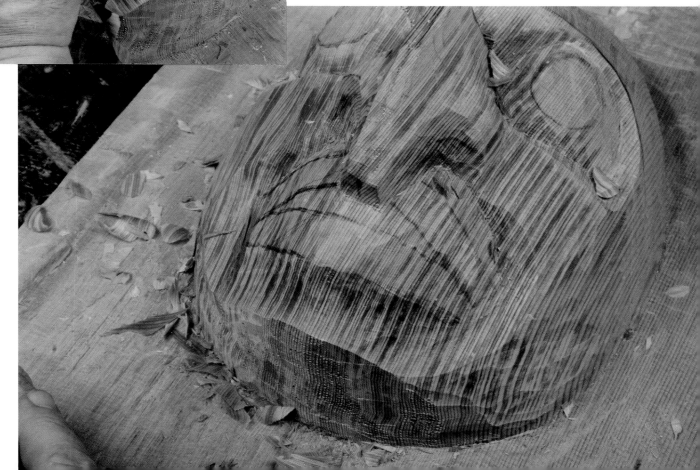

Cut the line of the upper lip at the opening...

Continue the bevel under the beak.

and carve back to it from the opening.

The lower lip should be shallower than the upper lip, giving the mask an overbite. Begin by deepening the area of the opening.

Taper the upper lip down to the opening.

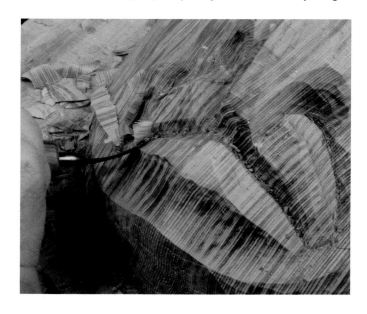

As you deepen the opening, reduce the lower lip.

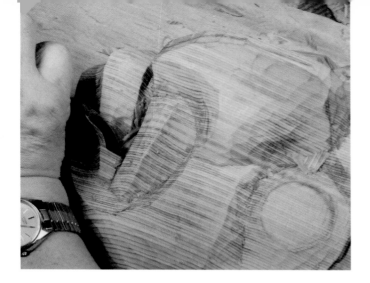

Shape the lower edge of the lip.

Open up the corners of the cheek and round the end of the beak.

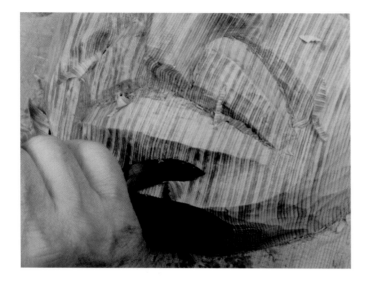

When the lip is shaped, clean up the chin.

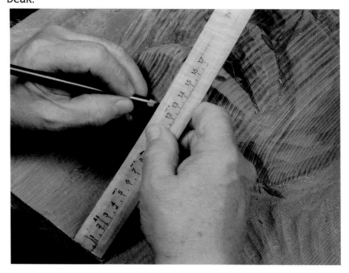

Reestablish the center line, bottom...

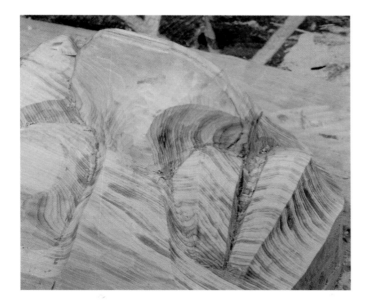

Mark the end of the beak and the line of the cheek at the nostril.

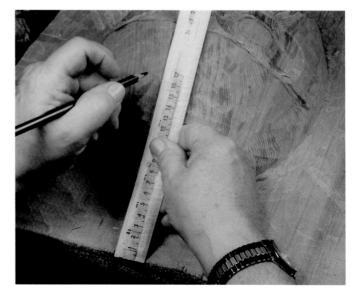

and top.

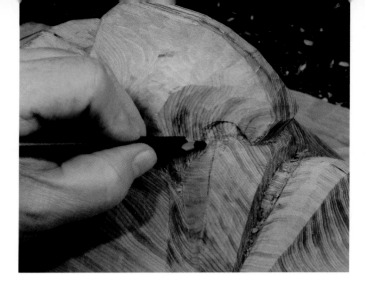

This area under the beak will be cut through, but this will wait until the back of the mask is hollowed.

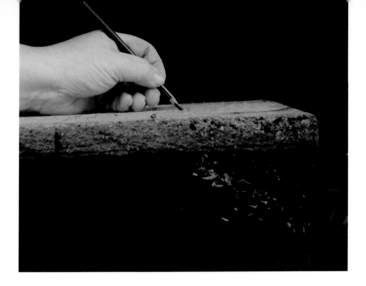

Look down the edge of the board to establish the inside of the mask. At this time you should allow for about 1" of thickness in the facial portion of the mask. The final thickness of the mask, where it joins the board is about 1/2". Mark the top, bottom and sides...

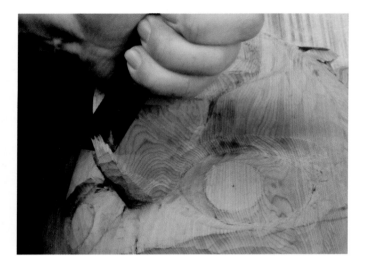

I use a slant blade knife for smoothing. This one is made from an old butcher knife, broken off and ground to the edge I want. I use it with a pushing action, giving me a lot of control. The point gets into some tight corners.

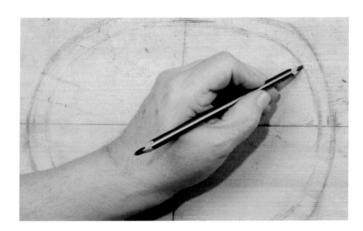

and connect the lines.

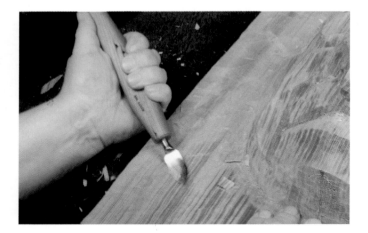

Reduce the board to its final thickness. The knife position is common for the crooked knife. The wrist is held in position and the thumb creates support for the knife.

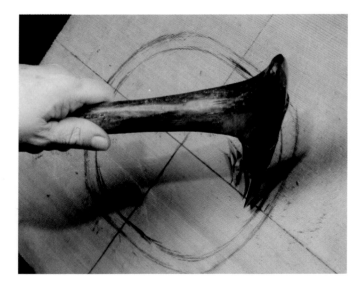

After covering the work surface to protect your carving, use the adze to hollow the back of the mask. Work from both ends, being careful not to go deeply enough to damage the carving.

SCHIFFER PUBLISHING LTD
77 LOWER VALLEY RD
ATGLEN PA 19310-9717

PLACE
STAMP
HERE

WE HOPE THAT YOU ENJOY THIS BOOK . . . and that it will occupy a proud place in your library. We would like to keep you informed about other publications from Schiffer Publishing Ltd.

☐ hardcover
☐ paperback

TITLE OF BOOK: _____

☐ Bought at: _____
☐ Received as gift

COMMENTS: _____

Name *(please print clearly)* _____

Address _____

City _____ State _____ Zip _____

☐ Please send me a free Schiffer Arts, Antiques & Collectibles catalog.
☐ Please send me a free Schiffer Woodcarving, Woodworking & Crafts catalog
☐ Please send me a free Schiffer Military/Aviation History catalog
☐ Please send me a free Whitford Press Mind, Body & Spirit and Donning Pictorials & Cookbooks catalog.

SCHIFFER BOOKS ARE CURRENTLY AVAILABLE FROM YOUR BOOKSELLER

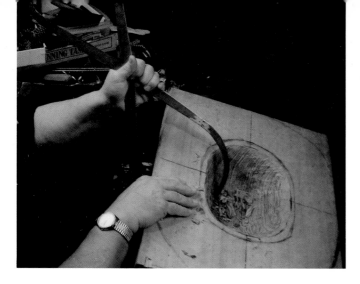

Double ended calipers measure the thickness of the walls. I do this often to determine progress and to prevent an unwanted cut through.

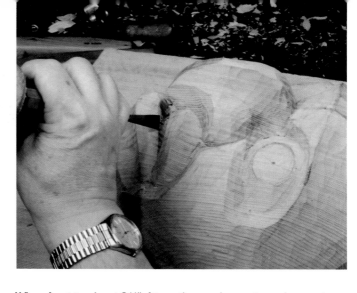

When I get to about 3/4", I turn the mask over to make a cut-through at the mouth working from the front. Using a chisel that has been ground to the shape of an adze blade, I deepen the opening in the mouth.

When I get to within an 1-1/2" or 2" with the adze I switch to the crooked knife to finish the cleaning.

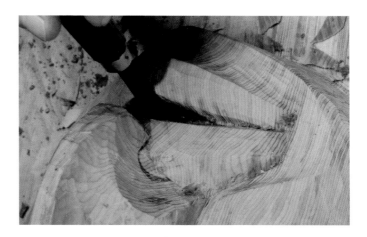

I want to go deep enough to just break through to the inside.

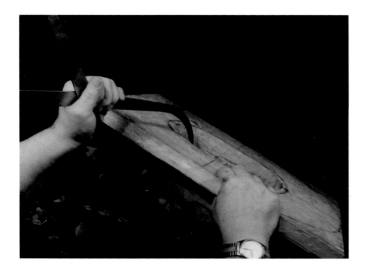

Measure again with the caliper. You need to get the measurement in one of the deeper spots of the face, like the area around the eye.

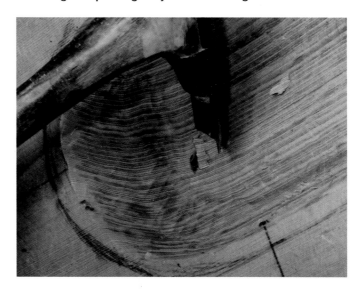

With the cut-through I can use the adze to enlarge it, giving me a reference point for completing the inside removal.

31

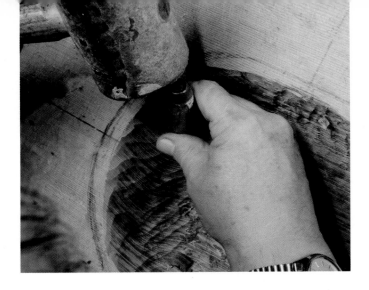

If the adze does not work for you, you can switch to a chisel and mallet.

When the hole is opened up some, I can get in with the crooked knife to enlarge it.

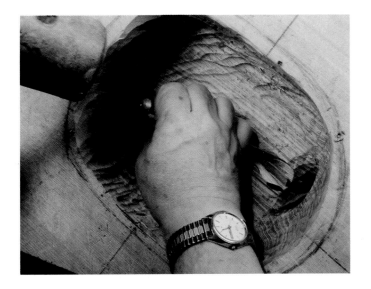

I now have the perspective I need to safely clean out wood with more aggressive techniques.

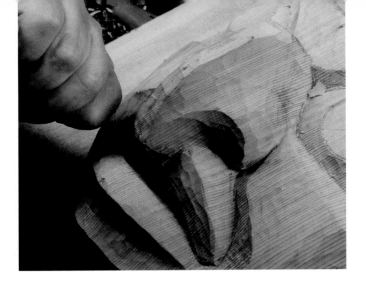

Working from the front, use a knife to open the mouth and establish the corners in the correct direction.

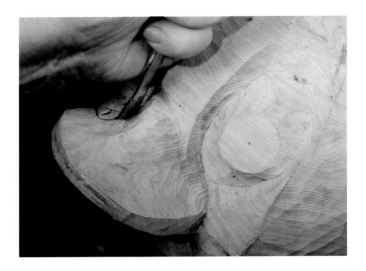

Use a gouge to define the undercut of the beak. Come at it from both sides

Return to the back to mark the position of the eyes and remove some of the excess.

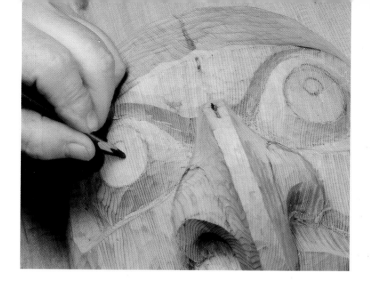

The eye hole is above the center of the eye. Mark it on each eye.

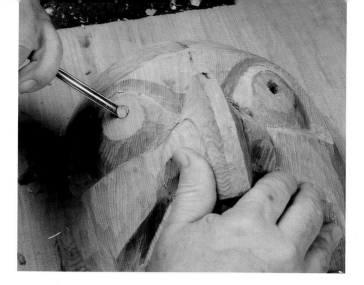

Repeat on the other eye.

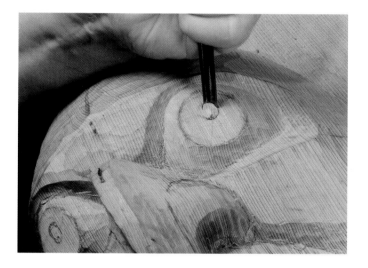

Begin the hole with a gouge, going around and around. This avoids breakage and the danger of marring the surface with a drill.

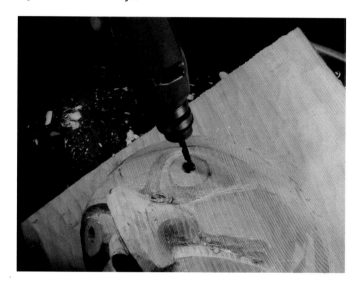

A drill with a bit smaller than the hole makes getting through to the other side much faster.

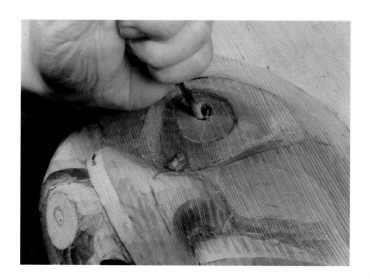

Continue deepening the hole. You may go all the way through to the back with the gouge or switch to a drill.

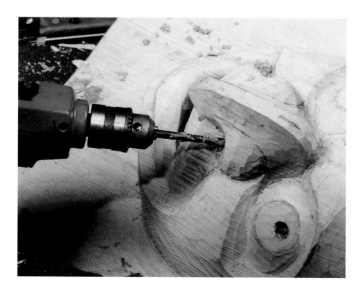

The drill bit can also be used to create a pilot hole for the nostril.

Open up the back of the mask around the eye hole.

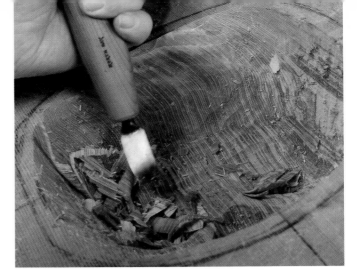

Continue on the forehead. For masks that are to be worn, we need to reduce the weight as much as possible by thinning.

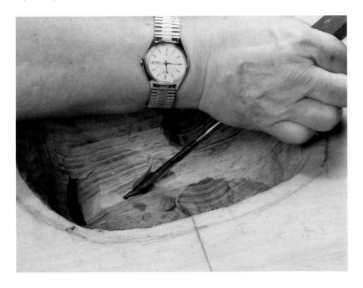

Do the same at the nostril, removing enough to expose the hole. Be careful not to thin the mask too much.

Open up the nostrils.

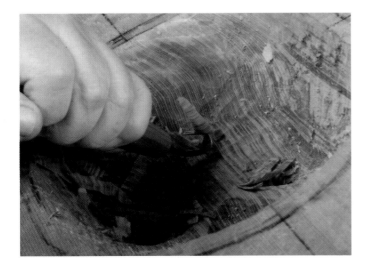

When you reach the pilot holes for both eyes and the nostrils, you can begin removing the area of the cheeks with less danger of cut-through.

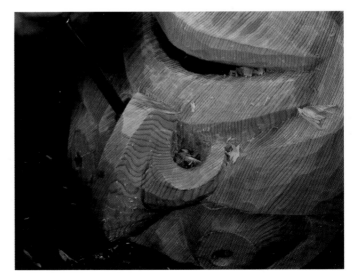

Continue widening all the way through to the back. This is a good source of ventilation for the wearer, and some dancers like to look out through the nostrils to get their bearings.

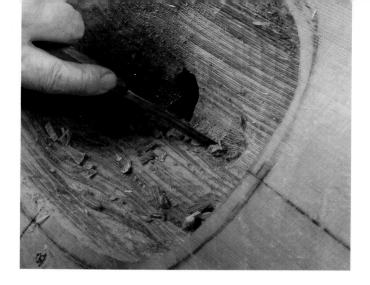

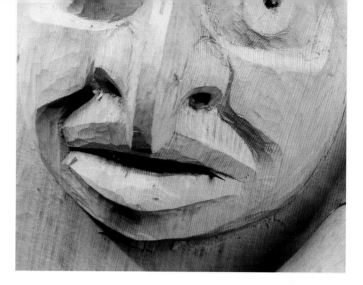

When you have gone fairly deep, turn the mask over and remove wood from the nose area until the chisel hole is exposed. You want to be careful not to go too deeply or too thin.

Work from back and front to refine the mouth.

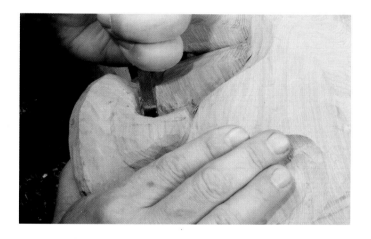

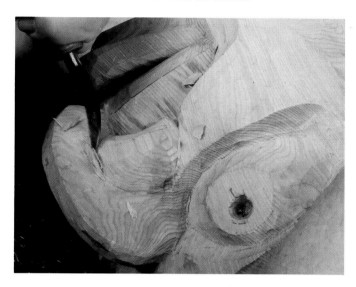

Return to the front and clean up the hole, making it flat on the lip side and round on the nostril side.

Strengthen the line between the nostril and the beak.

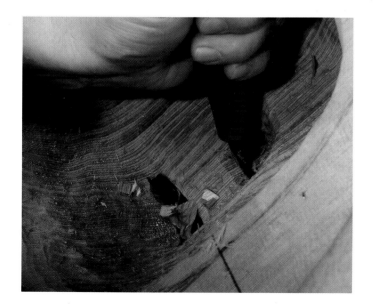

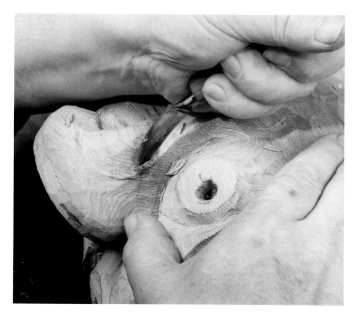

Turn the mask over and clean up the nasal area in the back.

Continue around to the cheek.

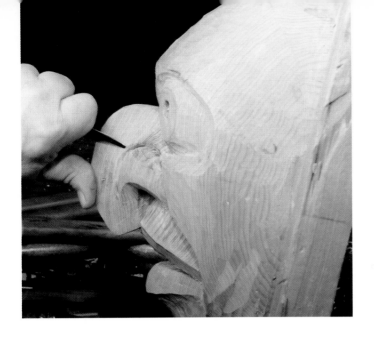 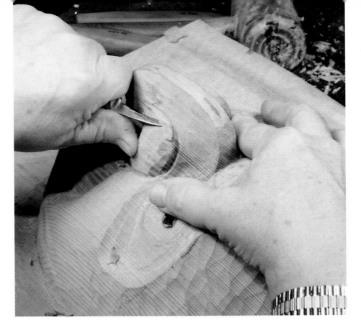

Reduce the surface of the beak to meet the line of the nostril. Do the same with the surface of the nostril.

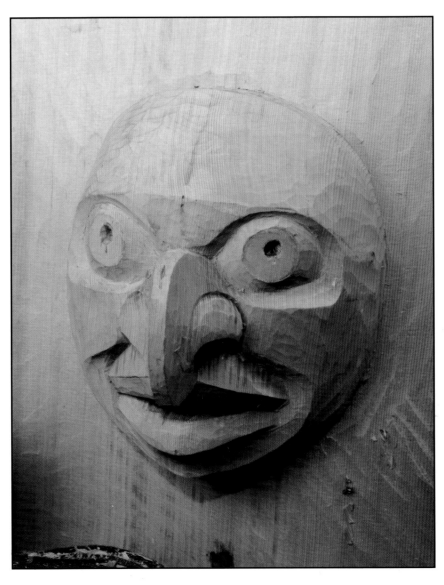

Progress.

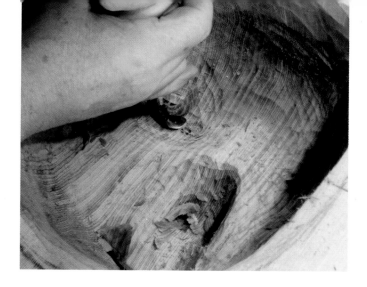

Thin the area of the eyes from the back.

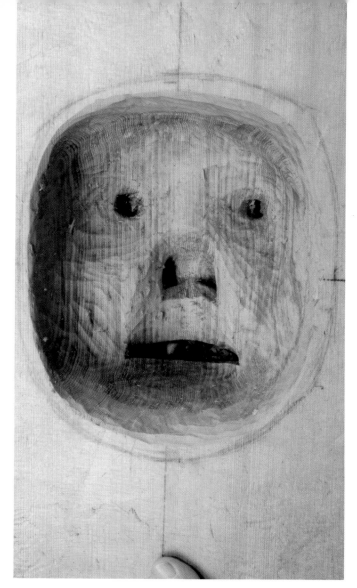

The back is ready for the drying stage.

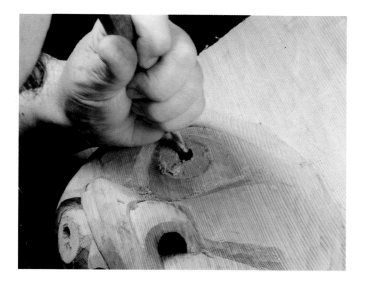

Working from the front with a gouge, clean up the holes of the eyes through to the back.

In the back, make the inside of the eye hole bigger than the outside. It will taper smaller as it moves toward the front.

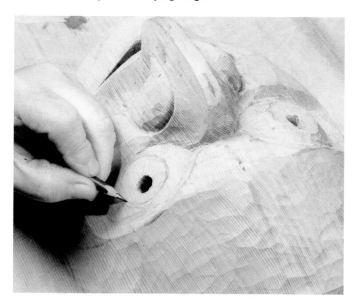

The eye center is three non-concentric circles around the pupil. First reestablish the outer circle.

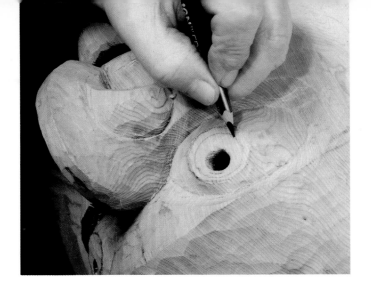

Next draw an inner circle slightly smaller...

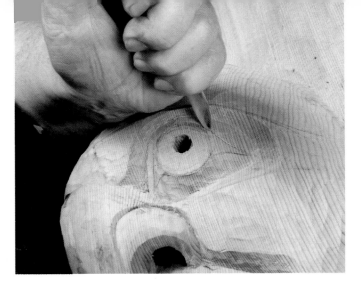

Incise the line of the eye...

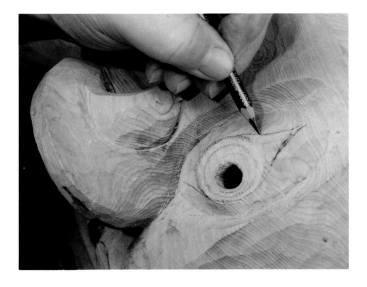

and a third circle smaller yet. The old style eye has crisp lines that come tangentially off the outer circle and flow into the corners, front and back.

and cut back to the cut from the surface of the eye. On this cut the knife should follow the line of the first of the outer circle as you go around the eye center.

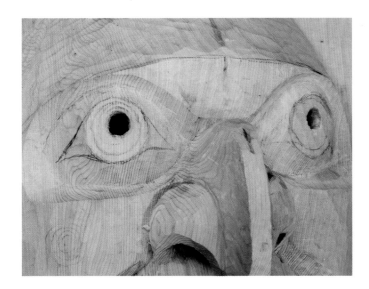

The eye drawn.

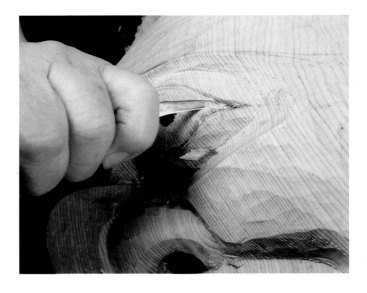

Bring the surface of the eyeball down to the level of the cut.

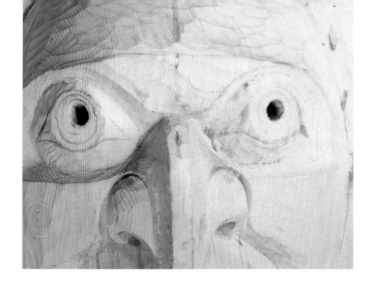

One eye finished.

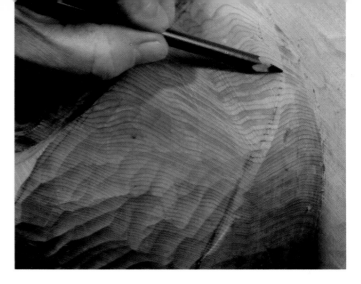

Measure with calipers to be sure the top of the forehead is the same on both sides. Mark any area that needs adjustment.

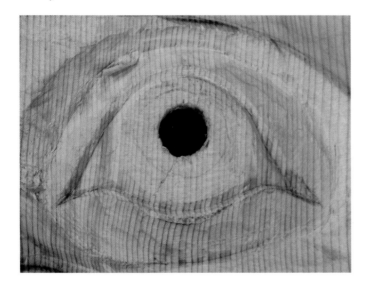

A close-up view of a finished eye.

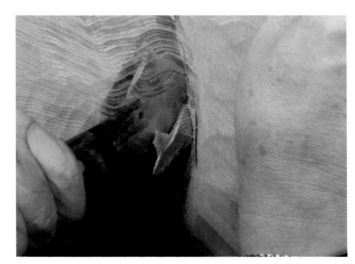

Trim the top of the head as necessary.

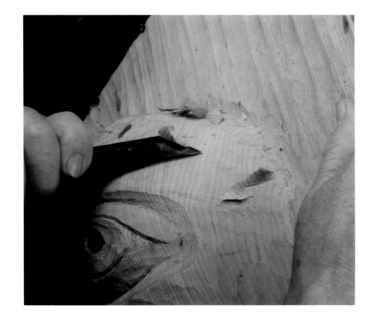

Smooth the forehead in preparation for the eyebrows.

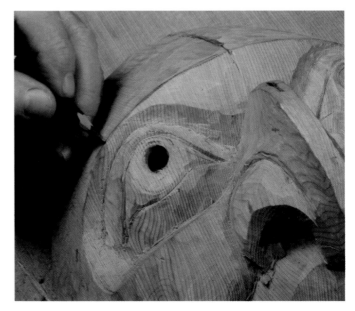

Redraw the brow line.

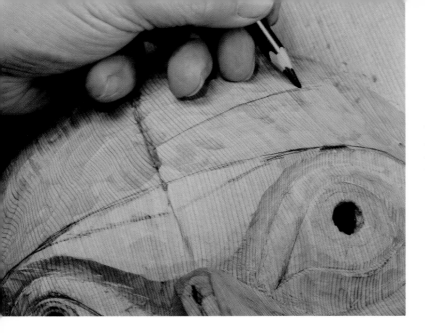

The bottom edge of the eyebrows follow the brow line but dip down toward the bridge of the nose at the center. The top line of the eyebrow is drawn parallel to the bottom and about 3/4" above it.

The top line flares out a little as it goes into the temple.

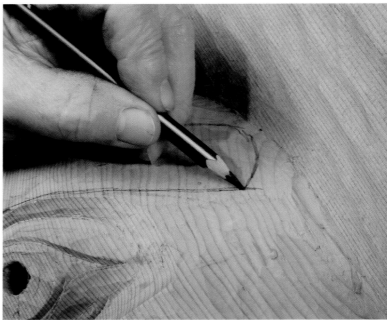

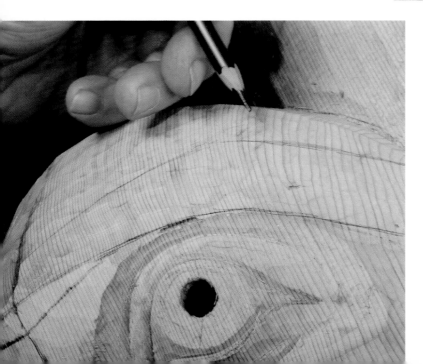

Connect the top and bottom lines at the temple.

Use the calipers to assure that the two sides of the eyebrows are symmetrical.

Incise the eyebrow line.

Cut back to the line to create a v-cut.

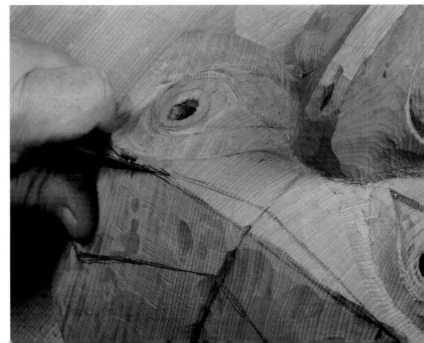

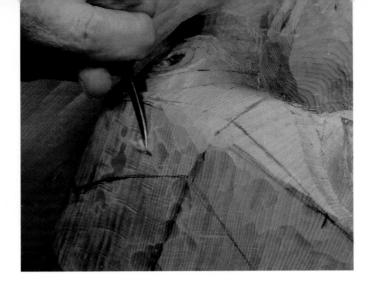

Blend the brow ridge into the eyebrow.

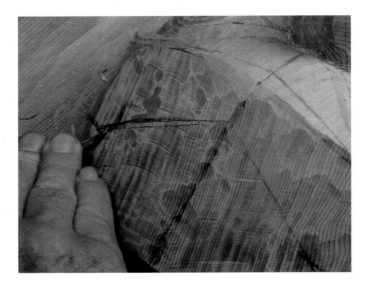

Cut around the rest of the eyebrow in the same way.

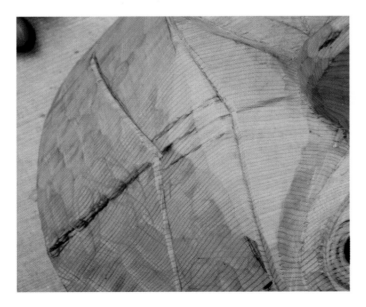

Redraw the center line in the eyebrow and make a mark on each side of it for the separation.

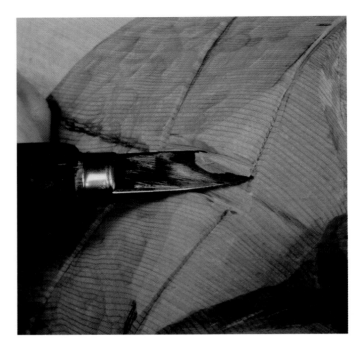

Incise the lines of the separation and clean out between them.

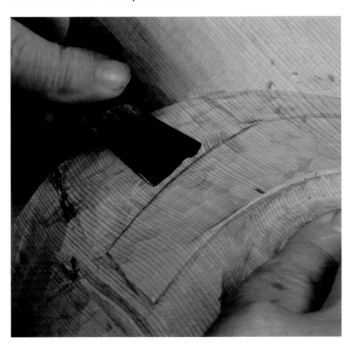

Relieve the area around the eyebrow.

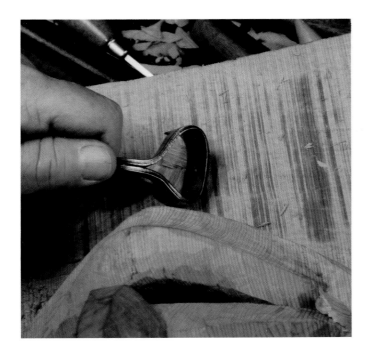

Reduce the board to a uniform thickness. The scorp works well when the wood is relatively dry, as this is.

Clean up the surface with a rabbit plane...

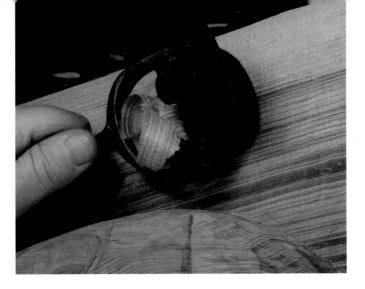

or a stave plane, a specialized tool used for making barrel staves. The curve in the blade leaves a surface that is not perfectly flat, having, instead, a little life to it.

Clean the intersection of the face and the board.

Refine the carving of the face.

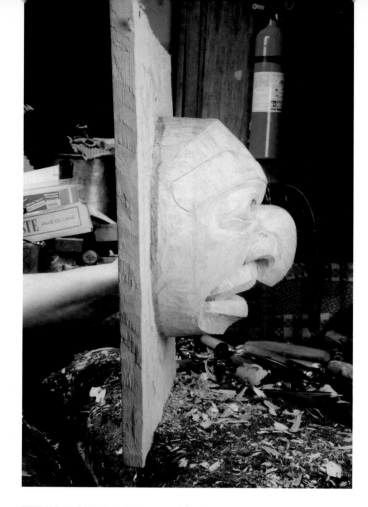
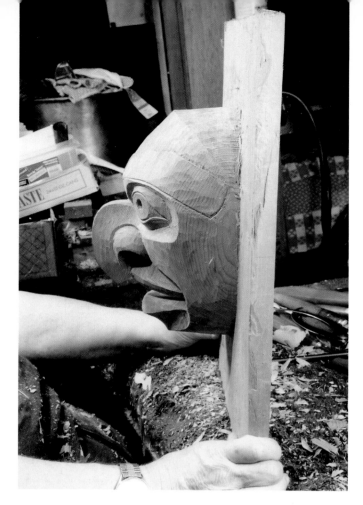
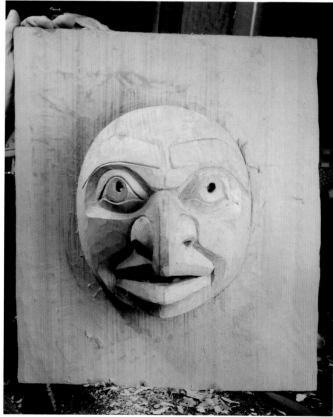
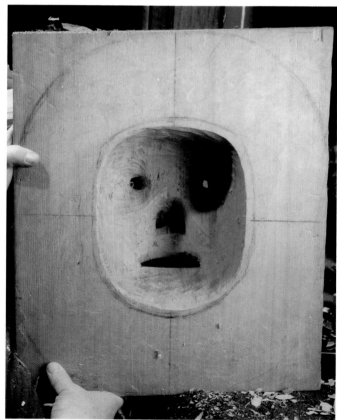

Ready for drying.

THE OUTER MASK

From a 24" block, froe a piece that is 4" thick and about 10" wide. Use the adze to clean it up. This tool is not pretty, but it works. It is the northern style of adze, and has some spring to it. The head was ground from an axe head.

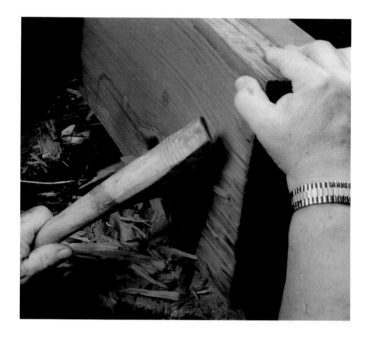

Roughly flatten the surface of the board.

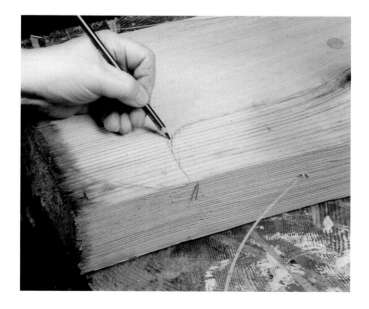

Draw in the profile of the side panel for placement. In this way I find that I am able to work it around the knot in this piece, saving wood.

Redraw the profile, and remove the area under the beak.

To keep the knot from tearing out, I switch to a gouge-shaped adze and attack the grain from the side around it.

Once the area around the knot is clear, you can return to a more aggressive adze to continue the removal.

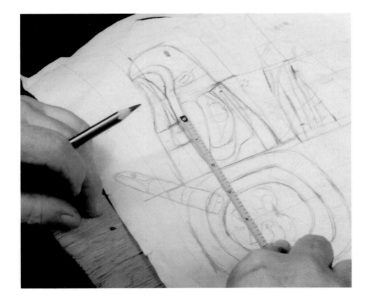

Take measurements from the drawing...

and transfer it to the mask.

Here are the two halves of the top viewed from the top. The diagonal of the beak goes toward the outside from a point about ten inches back from the front. This gives the thickness of wood needed around the mask when it is closed.

Reduce the inside of the forward beak to the line.

Check the angle of the bevel by holding it against the work table and measuring the height of the back of the mask. It needs to be high enough to cover half of the inner mask when the outer mask is closed.

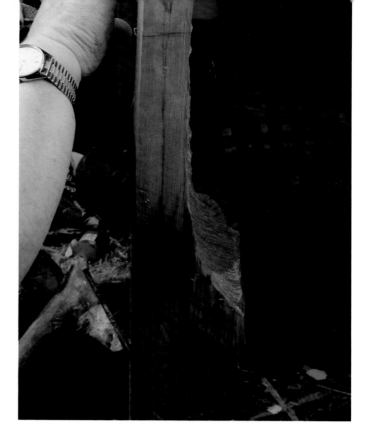

The result.

Moving to the outside surface, carve the space between the forehead and the beak.

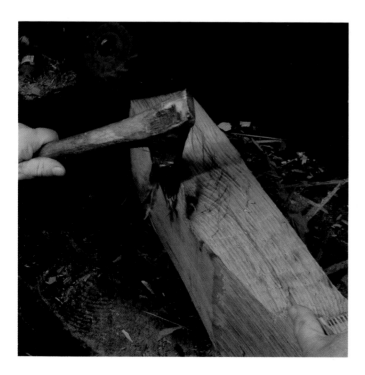

At the inside back of the mask, draw the area to be removed and take it out with the adze. Leave about 1 inch thickness to the wall.

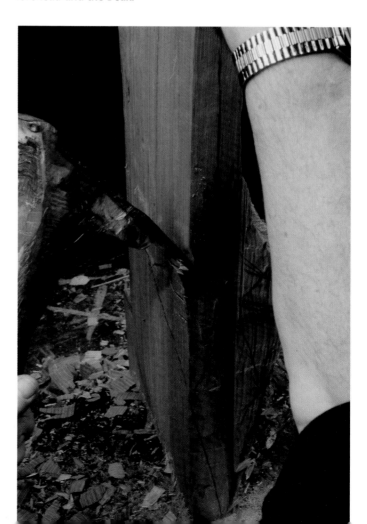

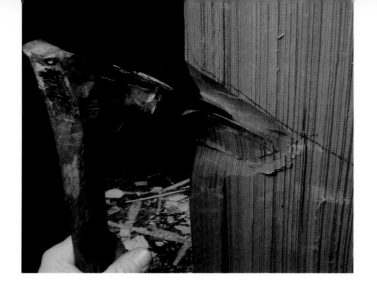

This is a triangular depression coming down from the top edge.

Draw in the features. The eye will be in the v-cut as will a cheek.

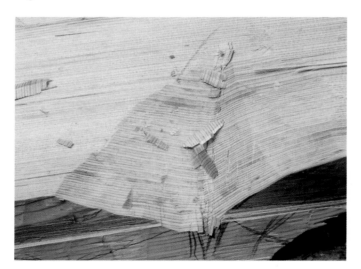

Looking down from the top edge you can see the progress.

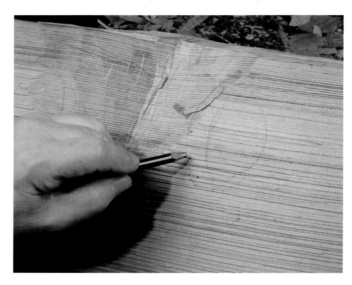

The beak will have a nostril...

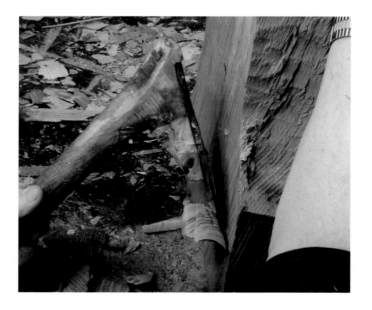

Refine the inside surface of the beak to set the angle. This is the last chance to do this easily.

and will curl up on the lower edge.

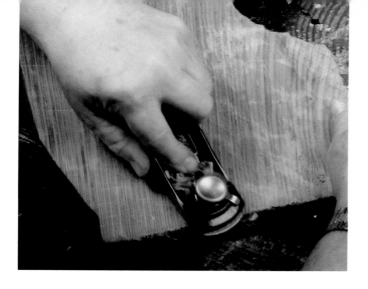

Smooth the surface.

and the high spots pick up the color. Carve away the high spots, and repeat the process.

When both the angle of the beak and inside of the back portion are set, you can reduce the area between them at the bottom.

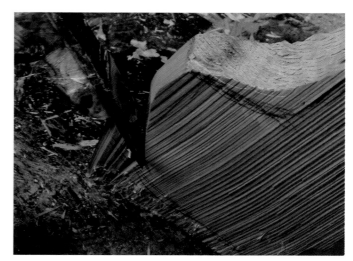

Round the end of the beak.

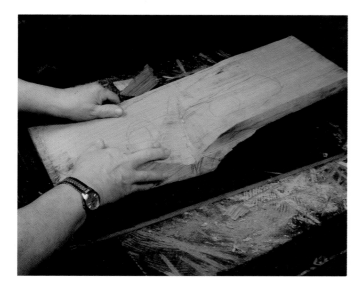

A board covered with lumber chalk is helpful in targeting high spots. Rub the carving on it...

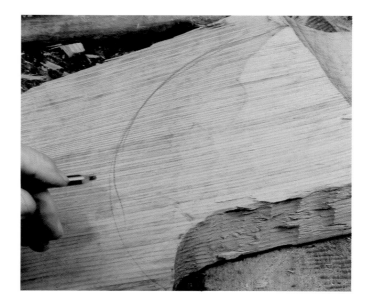

The beak will be hollowed out below and behind this curved line.

Round the top edge of the beak.

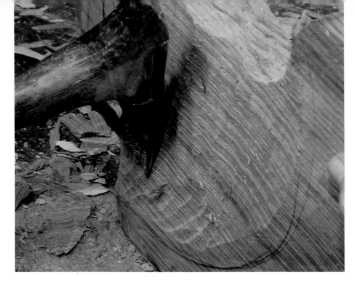

Clean out the area inside the beak that was marked earlier.

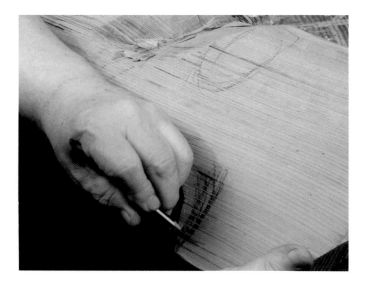

Redraw the features of the face.

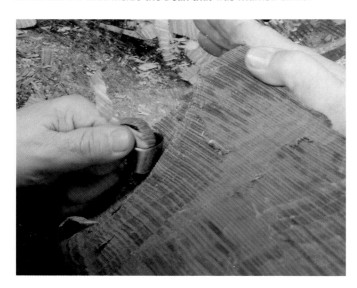

Smooth the area.

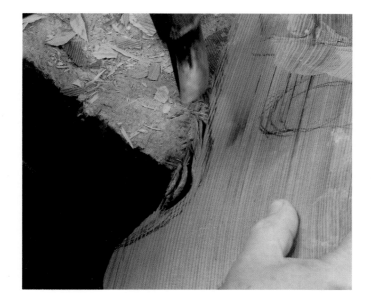

Carve away the area under the beak.

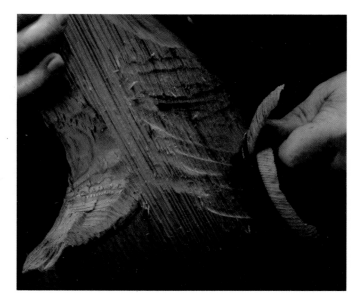

Moving to the outside of the beak, hollow out the area of the nostril.

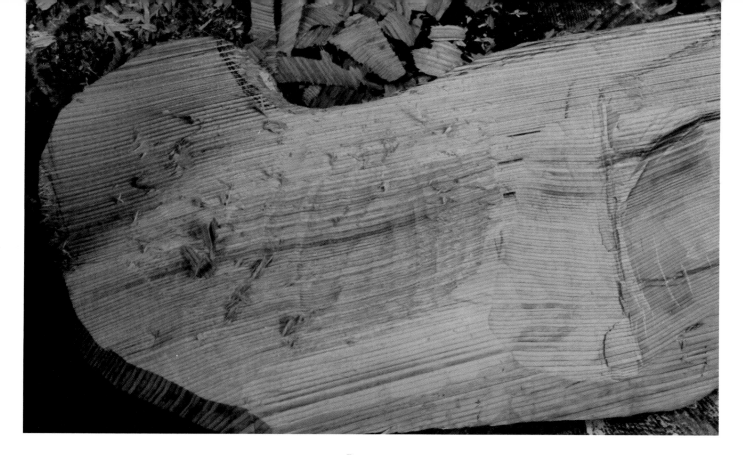

Progress.

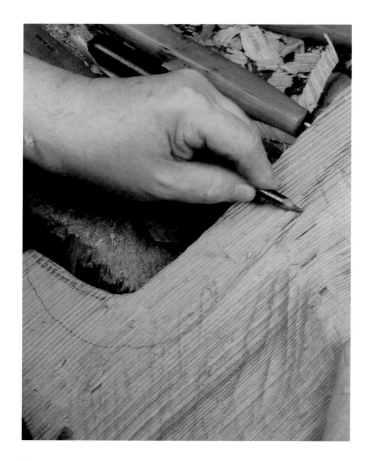

When the bottom edge of the beak is shaped, draw the line of the upper "lip."

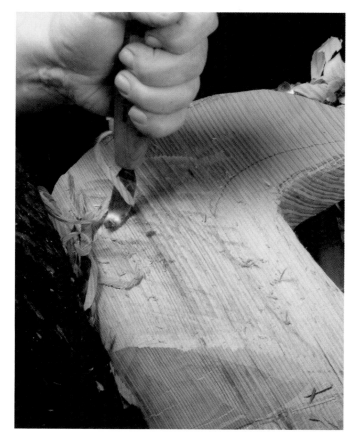

From the lip line, scoop the area of the nostrils.

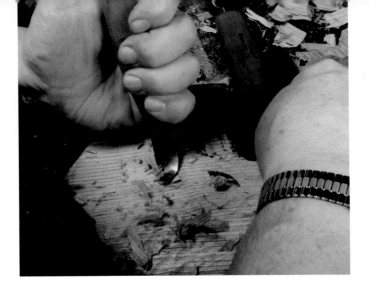

Continue around the end of the beak. The top portion of the beak will be reduced and the end rounded.

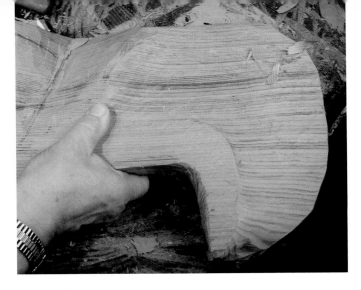

Progress. The beak tapers down from the nasal ridge.

Redraw the nostril.

Give more definition to the line between the beak and the head.

Continue thinning the beak in front of the nasal ridge and above the lip ridge.

Relieve the area of the face below the front corner of the eye, bringing out the roundness of the eye mound.

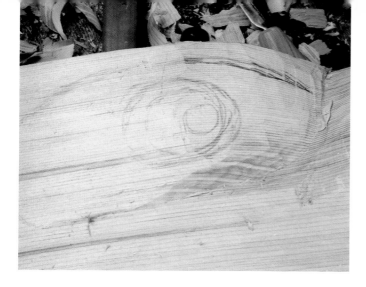

After smoothing the surface of the head, redraw the eye. Like the inner mask, it is a series of non-concentric circles.

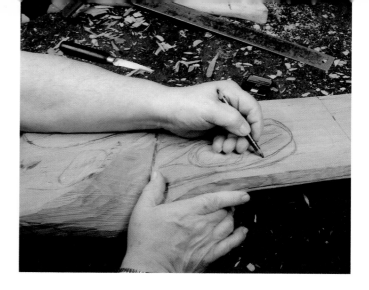

Redraw the designs.

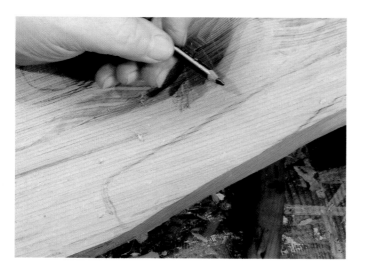

Continue the upper lip back to beneath the eye.

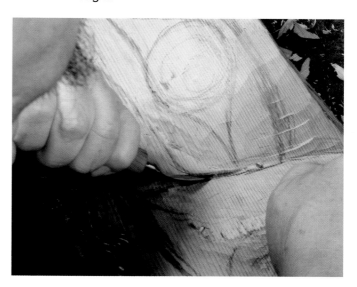

Clean out the area around the eye.

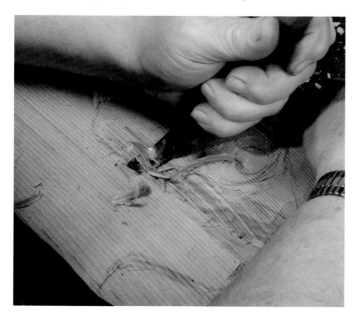

Shape the area around the eye.

Shape the forward eye mound.

Continue above the eye...

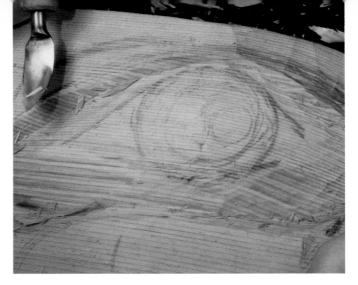

Progress.

and around the back, incising on the outer eye line...

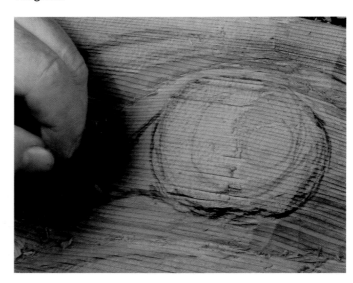

When the eye mound is carved back to the first concentric ring of the iris, redraw the lines.

and cutting back from the eye center.

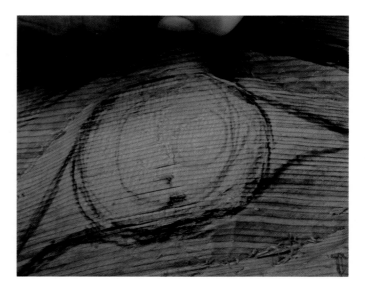

Incise the lines of the corners of the eye...

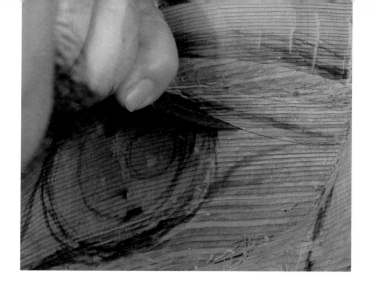

and cut back to them from the eye ball.

Go back and clean up the cuts.

Continue all the way around the eye.

Shape the front edge of the eyebrow.

Round over the facets created at the corners of the eye.

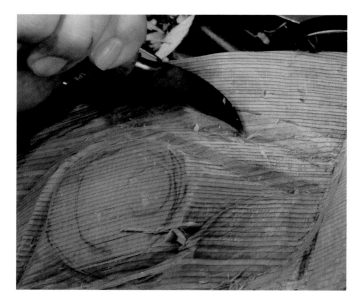

By rolling the bottom of the eyebrow toward the corner of the eye, you can create a ferocious expression.

Shape the front of the cheek, cutting a v-channel between it and the beak.

Shape the beak in front of the eye.

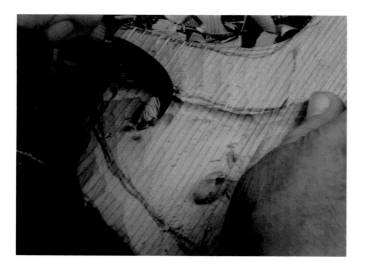

Deepen the channel around the beak flange...

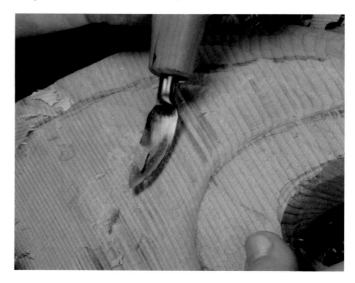

Clean up and shape the forward portion of the beak.

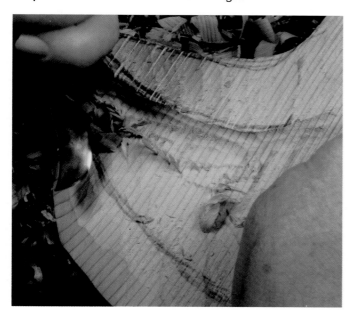

and blend it into the beak.

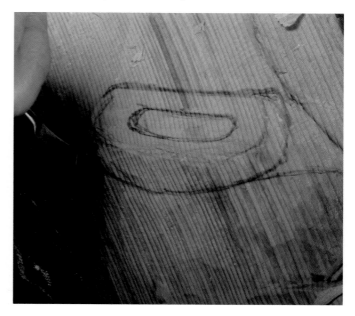

Redraw the nostril and incise its out line.

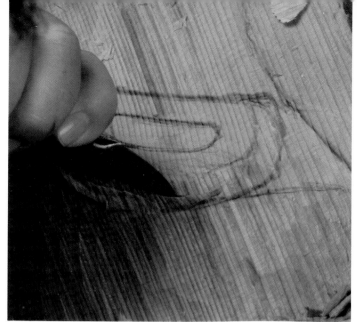

Cut back to the incised line from the surface of the nostril ridge.

Clean out the triangle at the lower rear corner of the nostril.

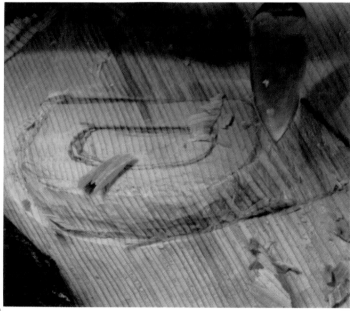

Hollow out the center of the nostril.

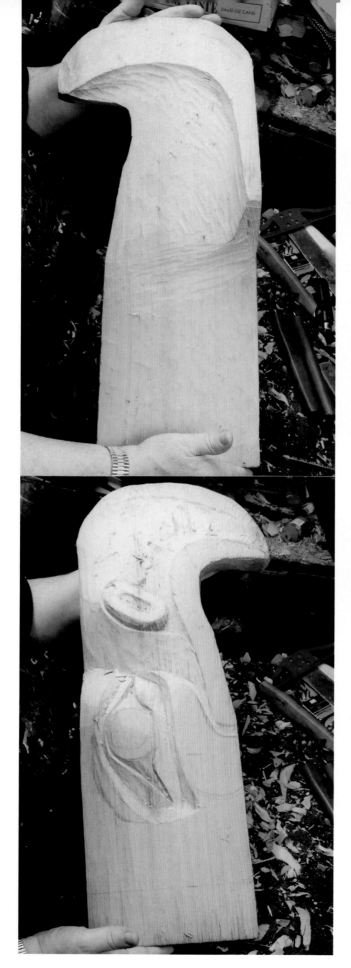

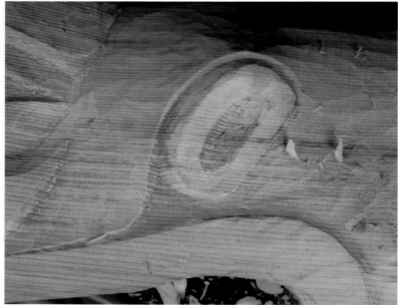

The side piece of the outer mask complete. The same process is followed for the other side.

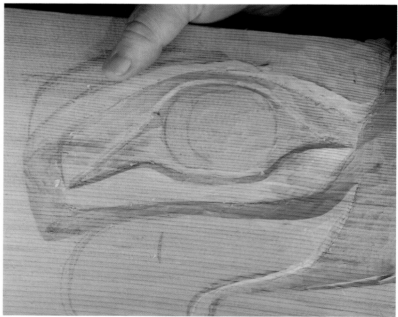

The blank for the cap piece is 11" x 11" x 4". The chain saw helps to cut the length.

The jaw piece is cut from a block 16" x 11" x 4".

Mark the center line on the jaw blank, then align the side panel of the outer mask on it and mark the outer line. Repeat on the other side.

I use a chain saw to cut in from the side to the line...

using two cuts to divide the side into thirds. This makes the removal of wood much more efficient.

Trim the sides with the adze.

Knock off the bottom corners of the jaw.

Continue to chamfer the lower edge of the jaw. The bottom surface tapers toward the front from about halfway back.

Shape the sides to the line.

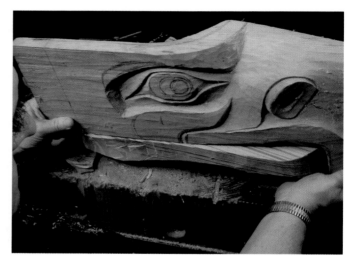

Test fit and make adjustments.

Cut the piece to length.

Widen the chamfer at the front of the jaw, beginning the process of rounding the forward part of the lower jaw.

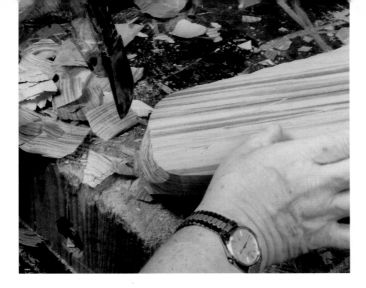

Round the forward part of the jaw. This flares out as it goes down.

Continue to chamfer the lower surface, rounding it over.

At the very back we need a flat surface for the hinge.

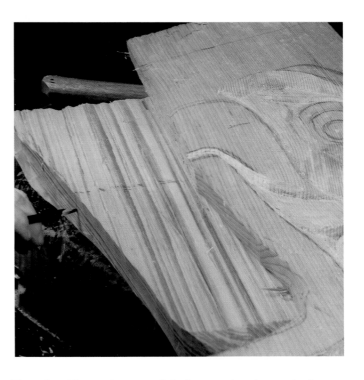

Place the side panel on top of the jaw panel and carry the lines of the side down to the jaw.

Reduce the back half of the upper surface of the jaw.

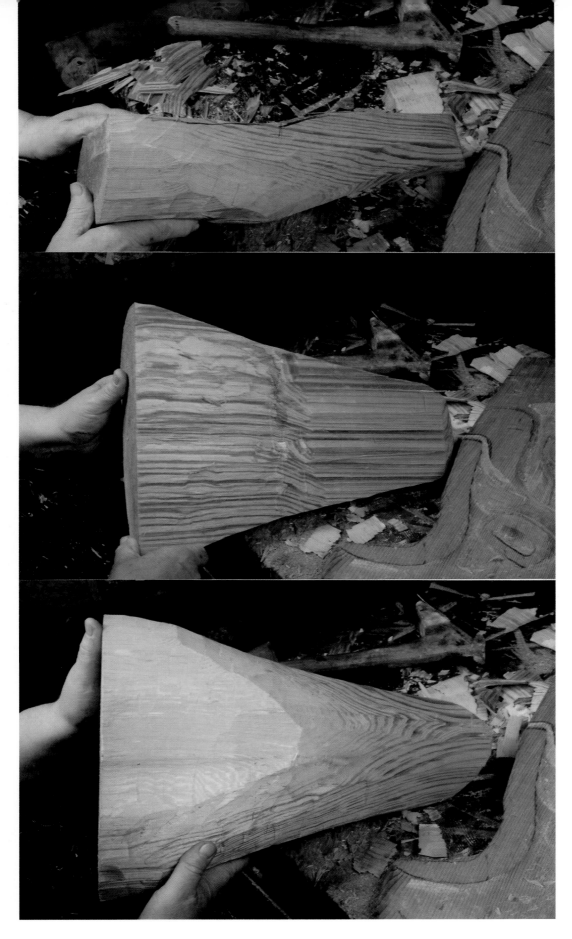

Progress.

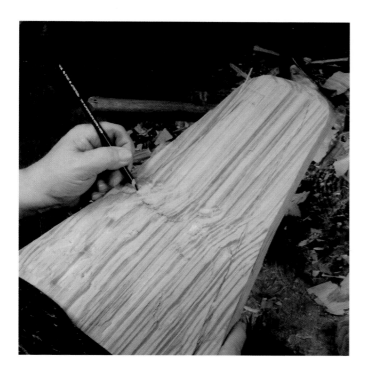

Draw in the walls of the inner jaw.

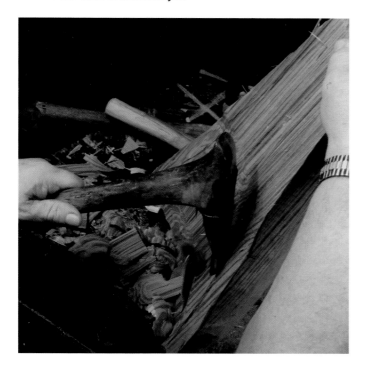

Hollow out the inside of the jaw.

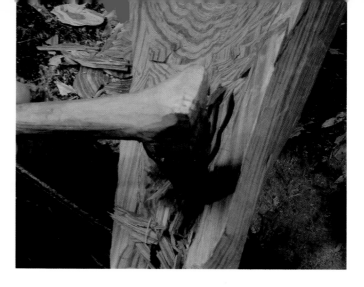

As I move toward the front, I switch to lighter, straight edge adze to help avoid breakage.

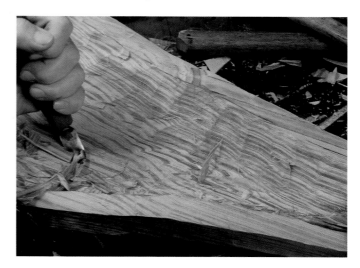

Clean up the hollowed inside of the jaw, using a crooked knife or a scorp.

Smooth the outside of the piece.

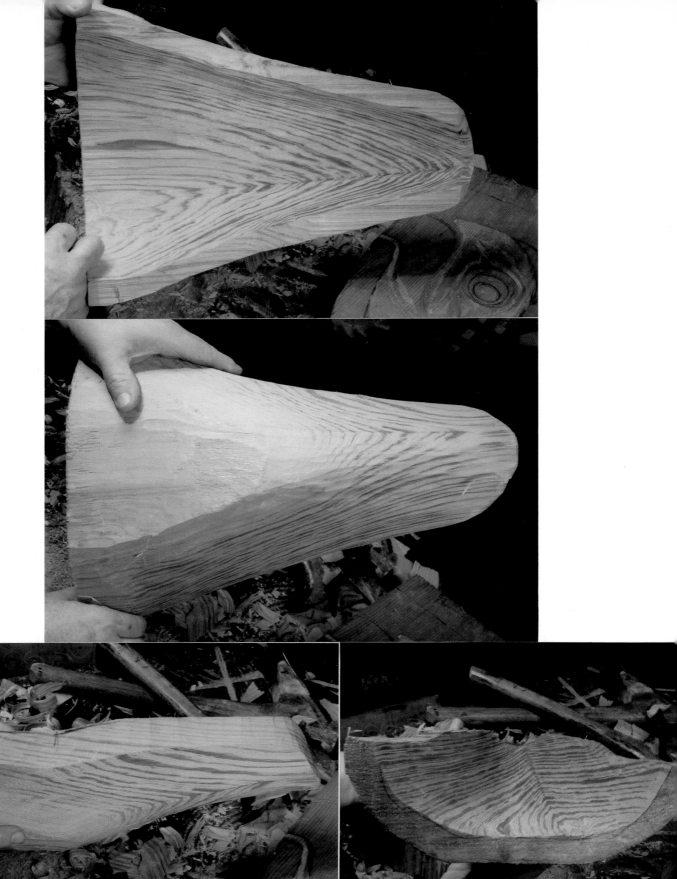

Progress. A little more refinement and it is ready to set aside to dry.

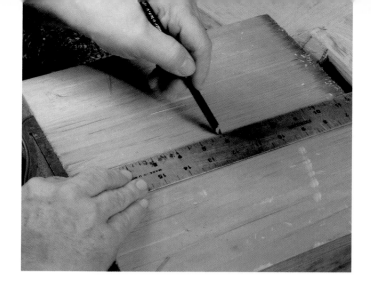

Mark the center of the cap piece.

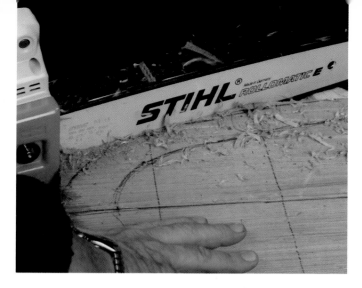

Knock off the corners of the cap. About now your arms may be getting tired, and you may wish to use that old traditional tool...the chain saw.

Align the side panel so the top of the beak is on the center line...

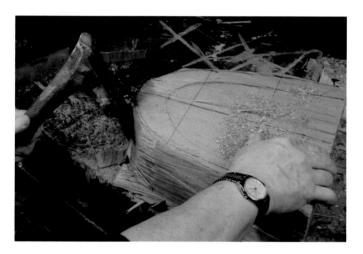

Clean up the cuts and refine the curve with the adze.

and mark the outside and inside. Though we only show one side panel for illustrative purposes, it is best if you use both together.

At the back surface of the cap piece, draw in the shape of the cap. There is about on half inch at the bottom for the stop, and an inch or so above that for the brow. The crown is about 3" to 3-1/2" from the bottom.

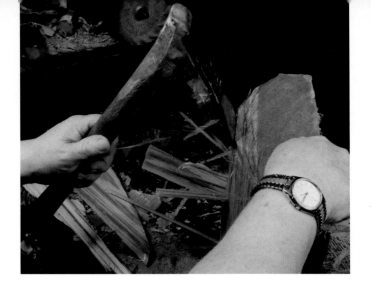

Knock off the wood to the shape.

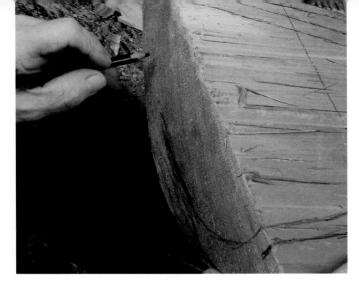

Draw a line for the inside of the stop.

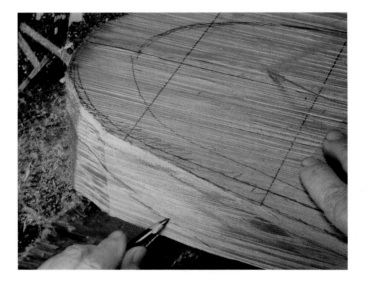

Draw the 1/2" stop and the forward slant of the cap.

Hollow out the inside of the cap to the stop.

Trim it down.

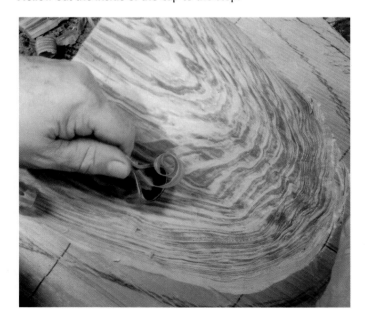

Scorp the inside smooth.

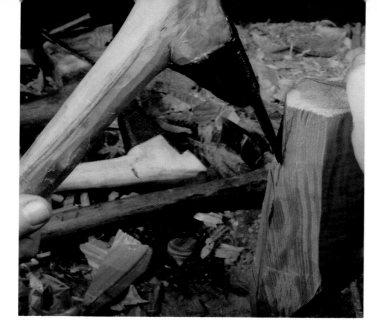

Bevel the lip from the outside of the stop to the edge.

Gradually square up the outside lip of the stop.

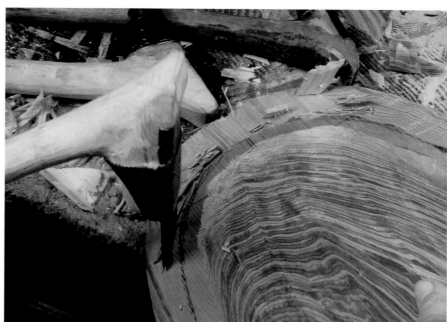

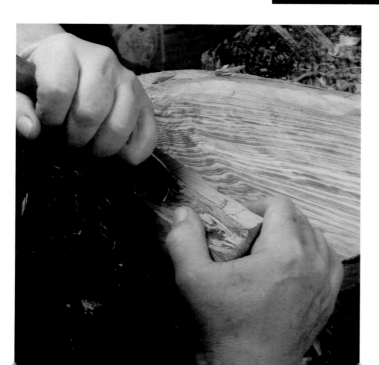

Clean up the cut with a knife.

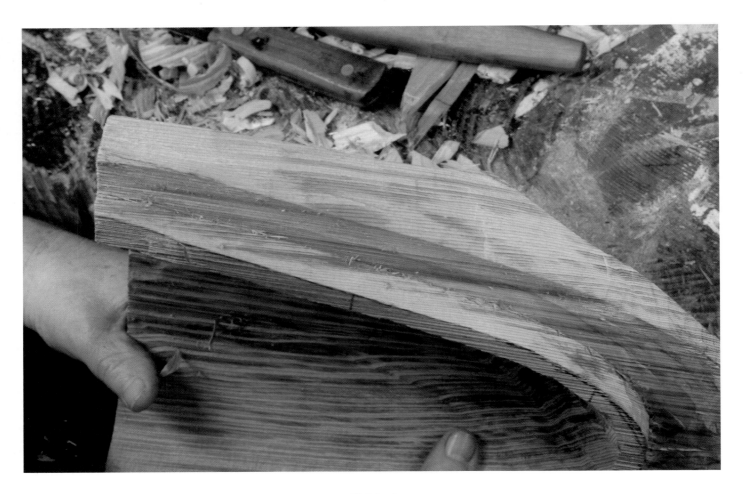

Finished.

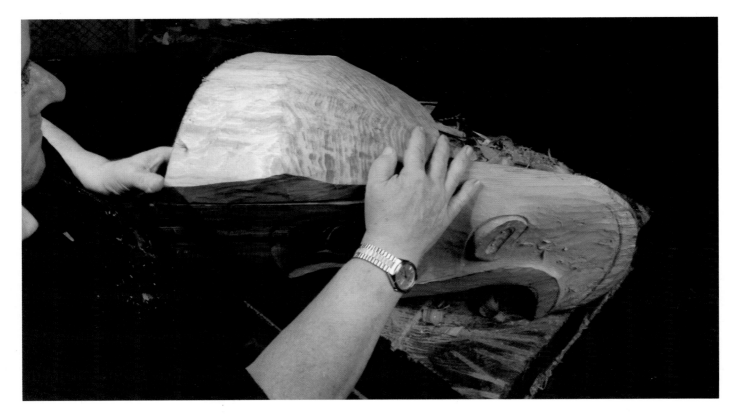

Test fit and make adjustments for a good fit.

FINAL SURFACE PREPARATION AND PAINTING

In the old days dogfish skin was used as sandpaper along with sandstone pumice. For oil some used ratfish oil, and some used nothing at all, though the paint tended to bleed into the grain of the wood if they did not. For fill they chewed up willow sticks, let them dry, then chewed them again along with spruce gum. This made a sticky substance that filled knot holes and other imperfections in the wood. They packed it into the hole and let it set up before sanding over it. Spruce gum was also used as glue. Another glue was made by cooking down fish skins.

The colors used in the masks are similar to theatrical makeup. The masks were used in ceremonies around fires, and the paints had to show well in those conditions. Bright colors were the norm, whites, greens, and certain reds.

Before trading paints were manufactured from natural materials: coal for black, copper treated with urine for green, iron earth for reds, and baked, pulverized clam shells for white. These were mixed with a binder, which was commonly the oil from salmon eggs. The eggs were wrapped in cedar bark and squeezed between the teeth. The oil rendered from the eggs along with the saliva was put in a clamshell cup where it was mixed with the pigment. When the traders came they made French verdigris, Chinese vermillion, and other pigments available. One of the geniuses of the Kwakiutl was their openness to new materials for the their art as they became available.

When working with cedar use a good, certified mask while sanding.

I start sanding with 100 grit paper on a sanding block.

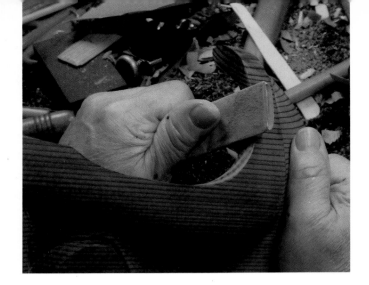

Take a paint stick or similar piece of wood, and bevel the edges on one side. When you wrap the paper around it you get a rounded side and a flat side, providing the versatility you need to get into the details of the carving.

and the rounded side works well on the inside of curves.

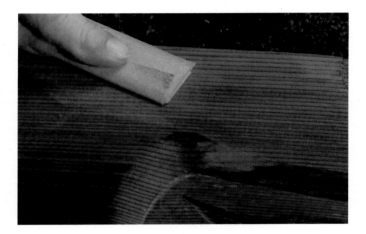

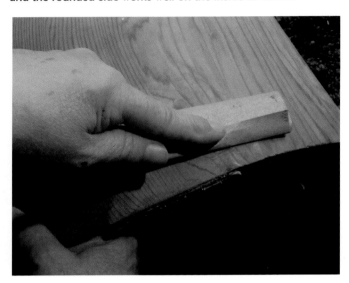

The flat side is good for the flat planes like this.

I want a satin-like surface. The course paper takes out the knife marks. I move from the 100 grit to 180 and finally to 220. I don't like to go finer on that on cedar. If you go finer you end up almost polishing the wood and lose the old look.

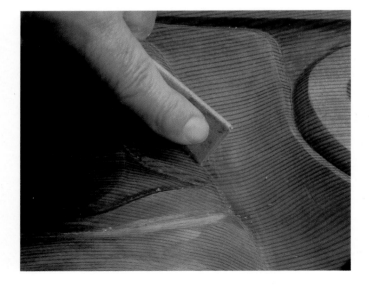

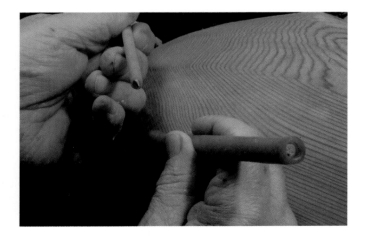

The edge gets into the crevices...

For unusual spots I use a dowel inside some rubber surgical tubing as the base for my sanding stick. When sand paper is wrapped around this I get a nice pressure on the wood.

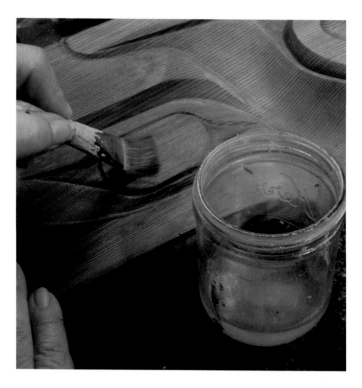

After sanding I apply a mixture of 3 parts turpentine, 1 part linseed oil shaken thoroughly. Set the piece in a place where it can air. I let it dry overnight if the air is dry, longer if it is damp.

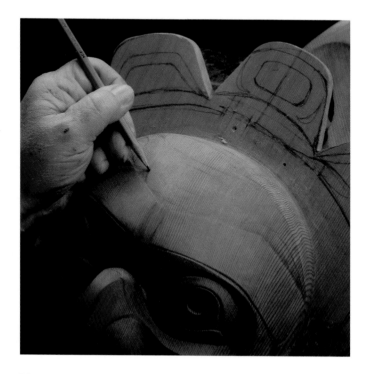

When the oil has set, you can draw in the lines.

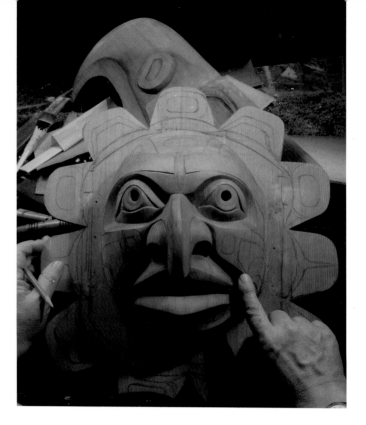

The painted designs are not prescribed. For the Kwakiutl carvers, the designs follow and complement the shape of the carving which is traditional. This particular mask represents a transformation. The inner face in general is a human face, but the nose is beaklike. The outer face is a more natural eagle form. The Kwakiutl's neighbor people, the Bella Coola (the name came from the Italian. A young ship's officer was in a longboat, came to a cove, saw a beautiful bend in the river. They call themselves N'halk, the people of the net), paint their lines in oppostion to the forms.

Traditionally porcupine guard hair and squirrel tails were used for brushes. They were pinched in a stick for a handle, bound with cordage and sealed with spruce gum. The barrel was round for easy twirling and the porcupine bristles were often cut at an angle like a pinstripers brush for fine detail. Today, of course, I usually use artist's brushes.

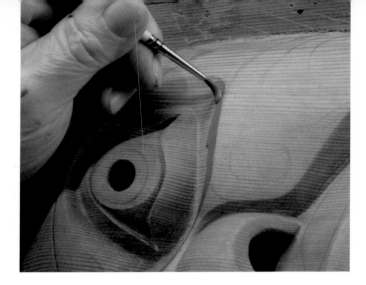

I use acrylic paints. They are available in colors that approach the original pigments. A green is used for the depressions like here around the eyes.

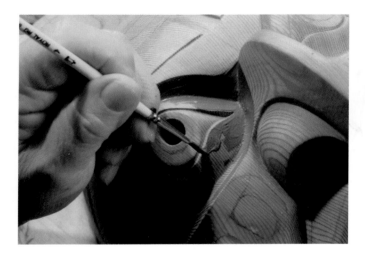

I like to apply a coat that is then enough to allow the grain to show through the paint. This gives the mask an older look.

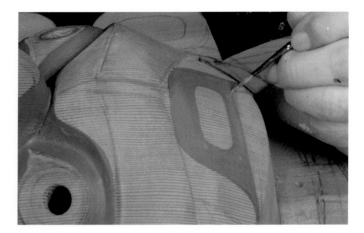

I continue with the green at the forehead. The pencil designs are covered by the paint, so when needed you can adjust the design for symmetry or to fix mistakes by simply painting over the lines. Go over the paint as necessary. Cedar tends to absorb some paint in a haphazard way so you will need to blend with further coats to get a consistant finish.

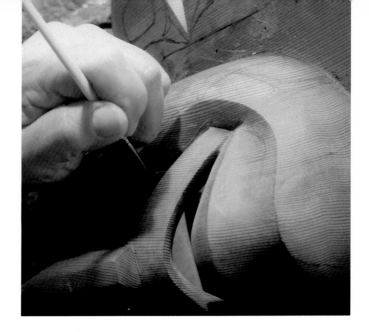

Continue down the depressions beside the nose to the corners of the chin.

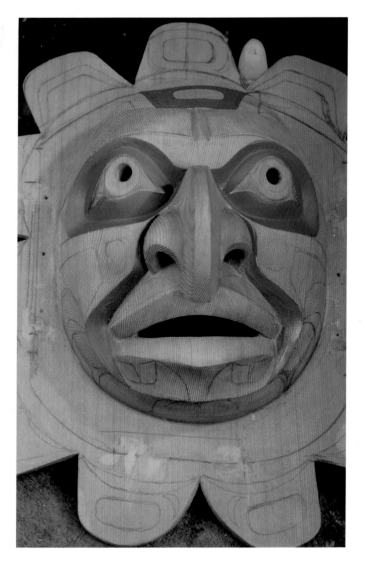

Progress.

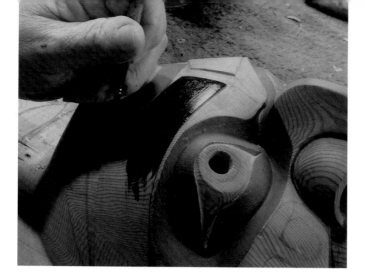

Black is one of the primary colors on masks. It is used for form lines, which are almost never seen in green or blue, but sometimes are found in red. Here I am using it for the dominant eyebrows.

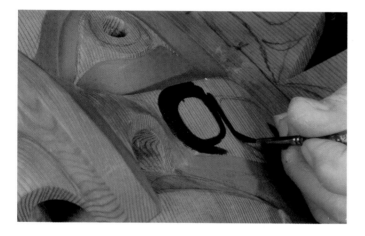

Continue with the black on the cheek design. You may see a small spot in the inner circle of the cheek, where a bristle of the brush put a speck of black where it is not wanted. A sharp blade will take care of that later.

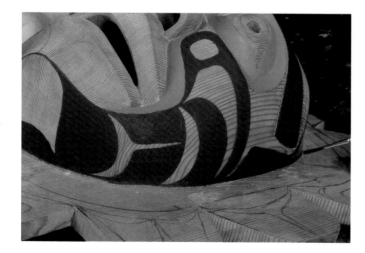

Use the black paint to create the design under the chin and up the side of the face to the top of the head.

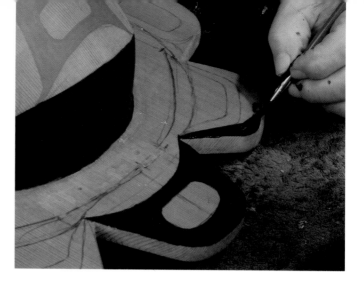

The fringe of the inner mask is next. This fringe is mostly decorative, but there are holes in it through which string passes which is used to open the outer mask.

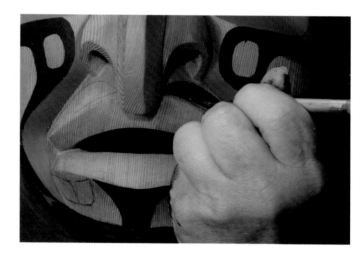

Before switching to red I paint the area under the lip, the moustache...

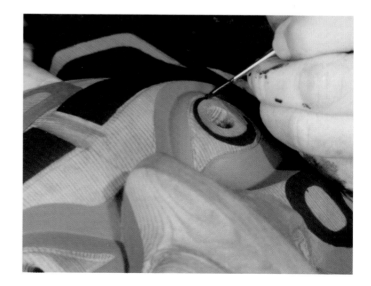

and the outer ring of the eye. The non-concentric circles of the eye is a typical design feature.

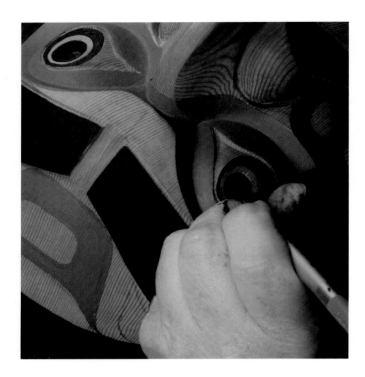

Paint the pupil hole black, carrying the color around the rim.

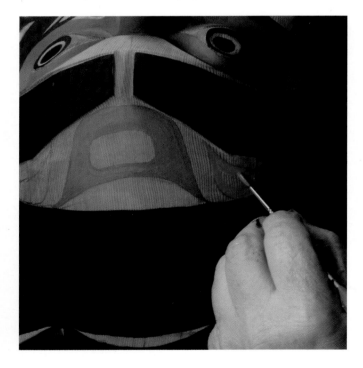

The application of red is next. The order is up to the artist. I am starting in the area above the brow.

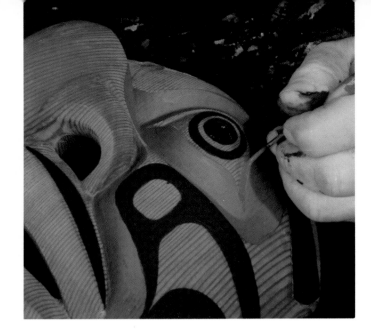

Paint the edge of the eyelid.

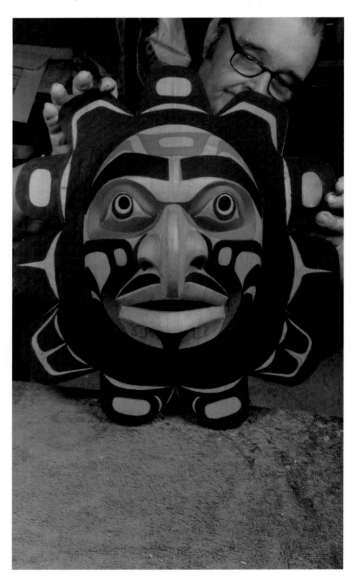

Progress.

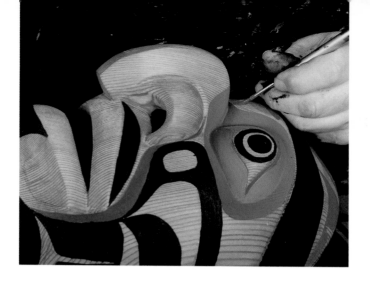

Continue between the eye and the brow...

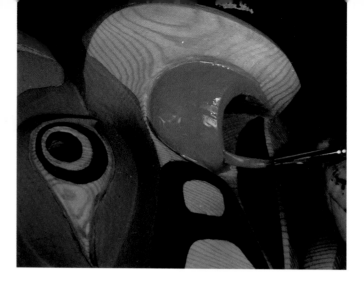

Do the other side in the same way.

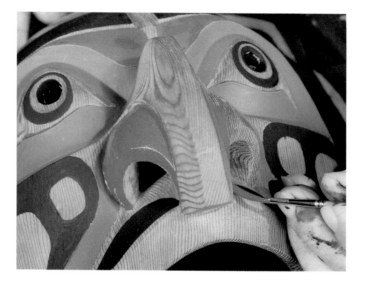

the nostril...

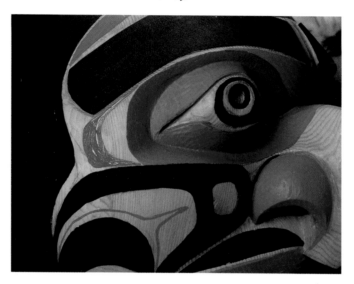

The red is also used to add some decorative work on the cheek and beside the eye.

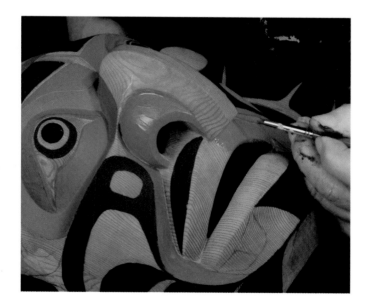

and the lips.

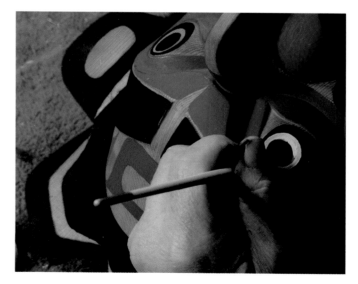

Paint the center ring of the eye white. This is carried right to the hole.

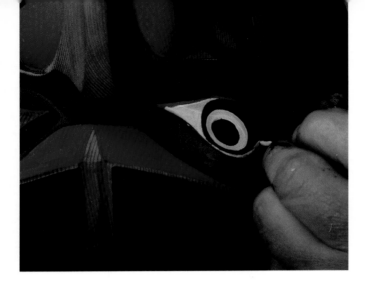

Continue with white for the eyeballs.

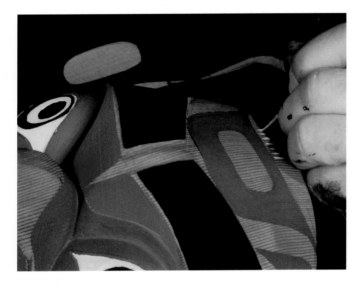

This area of the brow is thatched with white stripes.

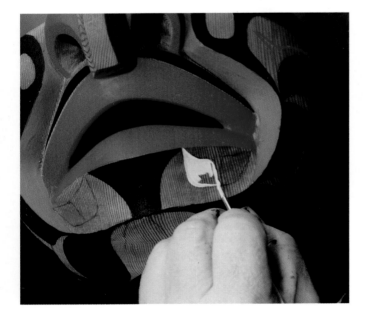

Fill the feather pattern below the lip.

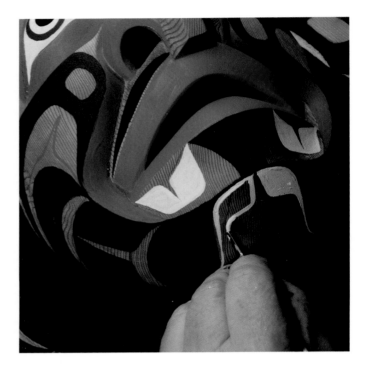

Create a feather pattern under the chin with white.

Continue with various other patterns, like this one on the lower cheek.

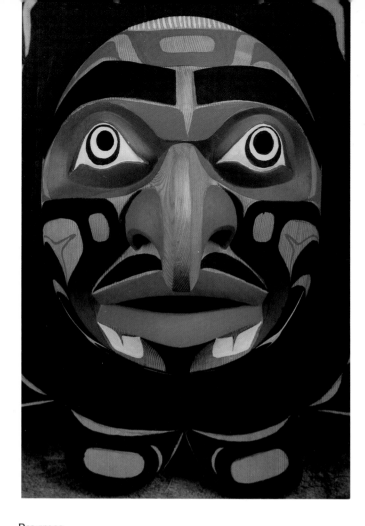

Progress.

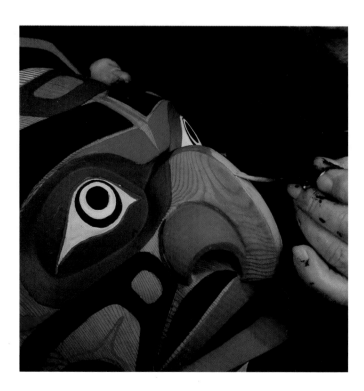

Apply a golden yellow to the nose/beak.

With the beak painted, I've decided to modify the design slightly by filling in most of the triangles beside the nose. Remember, there is no prescriptive pattern for painting this mask, so you are free to modify as you go.

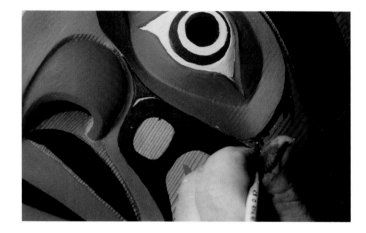

I also want to fill in the space at the side of the eye.

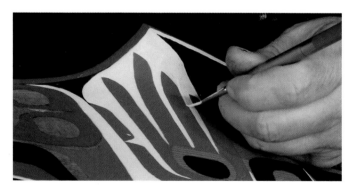

The inside of outer mask is painted next in the same way, and you can see the color patterns I used in the photographs that follow. The design and painting of the outside of the outer mask is not done until the final fitting is completed.

Before assembly, I want to go back and do some touch up painting. I look for thin spots, uneven lines, scrapes, smears, and so forth and fix them up by either cleaning them up with a knife or painting over. The white paint usually needs the most touch-up and I do this first. Here I am working on the outer mask.

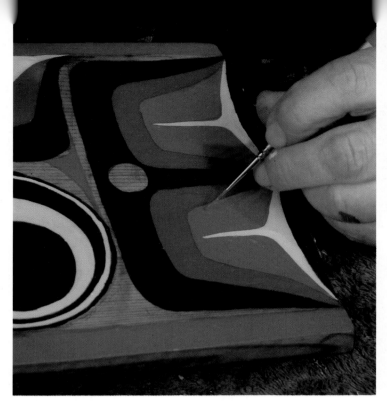

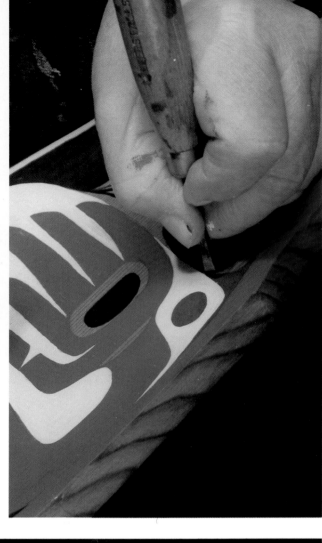

Continue with the other colors.

Where there is paint you don't want. gently scrape it off with a "steel eraser."

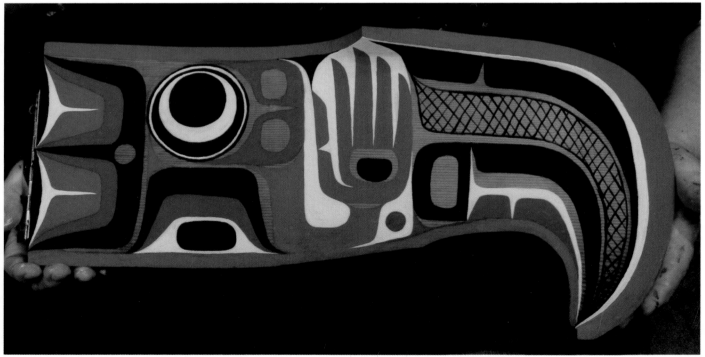

Ready for assembly. This is the inside of the left outer mask.

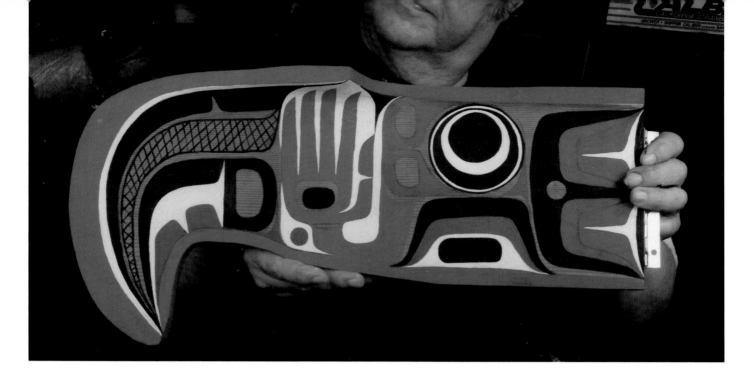

The inside of the right outer mask

The inside of the jaw piece.

The inside of the cap piece.

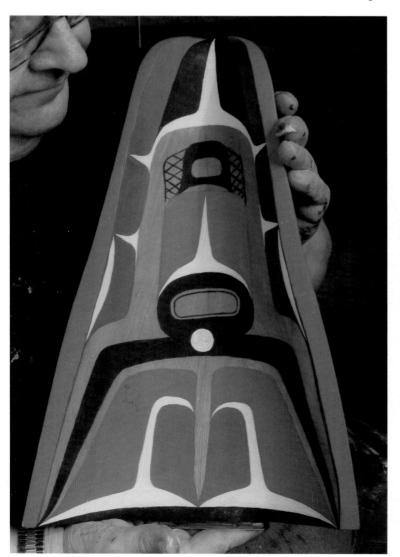

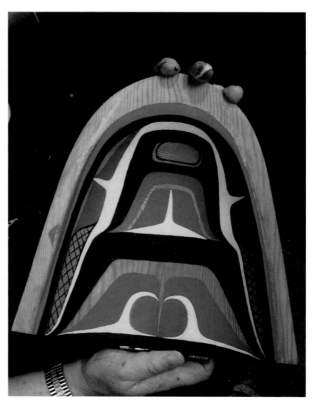

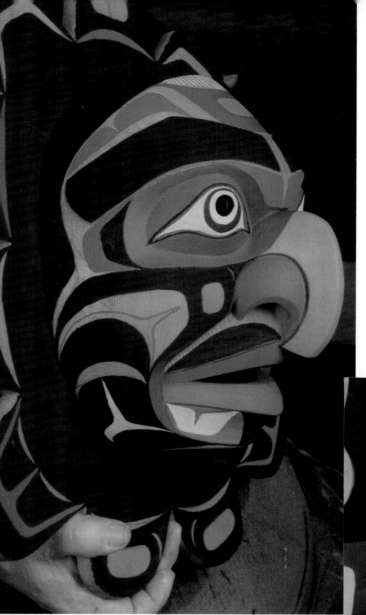

The inner mask, side view

The inner mask, front view.

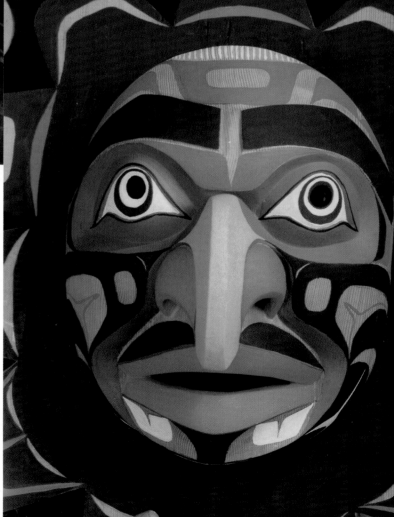

ASSEMBLY & FINAL PAINTING OF THE MASK

Having test fitted the pieces before and applied the hinge to the outer mask, I am ready for assembly. The hinge is a piano hinge, cut to size, and beat up a little to give it an older look. The carvers originally used sealion hide or other thick leather. They would drill holes in the wood, and use sinew, spruce root or other materials to sew the mask together. These early hinges would shrink or sag, making for a less-than-satisfactory fit. When trading began the Kwakiutl would salvage the hinges from Chinese tea chests for use in the masks.

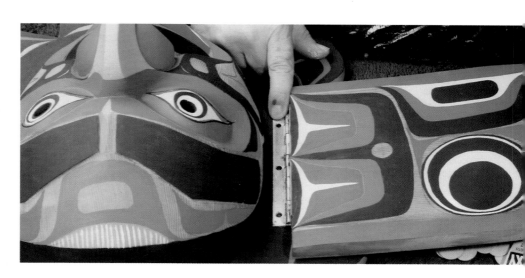

I apply epoxy to the joint between the hinge and the mask. I like the strength epoxy gives to the joint, particularly because I use the masks in the dance.

Screw a side panel of the outer mask in place.

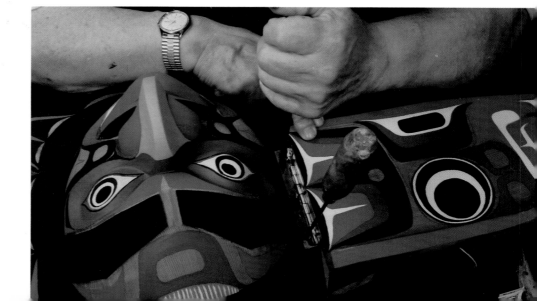

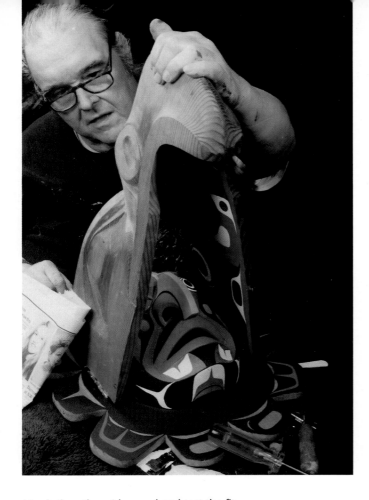

Put the cap in place and mark its position and the position of the hinge. Adjust the outer mask to accommodate it.

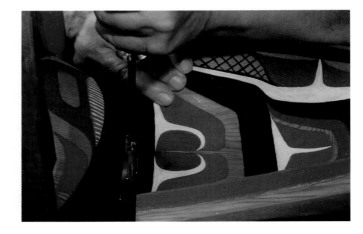

Attach the other side panel and test the fit.

Apply the epoxy and attach the cap in place.

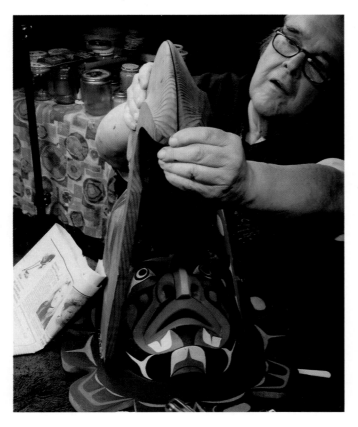

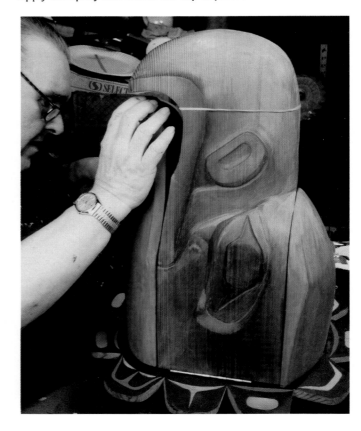

Pay particular attention to how the ends of the beak meet.

The lower jaw is last. Hold it in place...

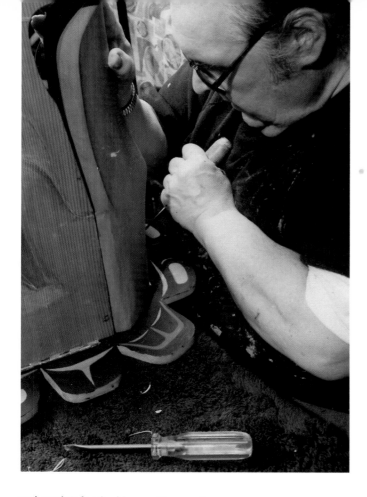

and mark it for the hinge with an awl.

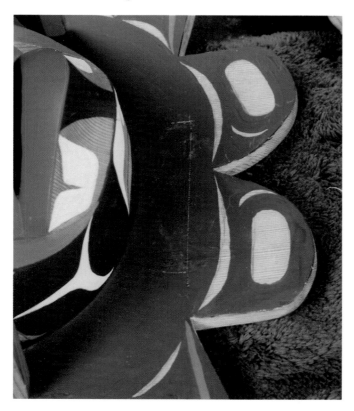

Here you can see the outline of the hinge.

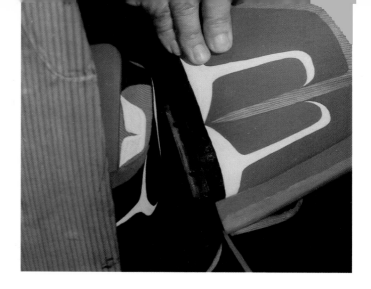

Align the hinge with the mark and make pilot holes.

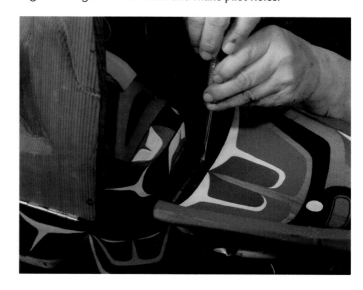

Epoxy the hinge and attach it. To get a more accurate fit, I allowed the hinge to set up with the mask closed before screwing it in place. When it was opened I was assured of a proper hinge alignment.

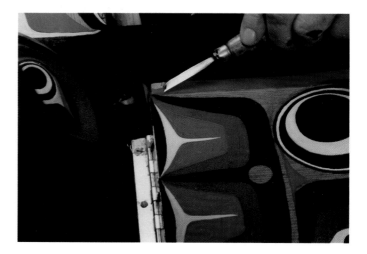

After assembly is complete some adjustments are necessary for a tight, but easy fit.

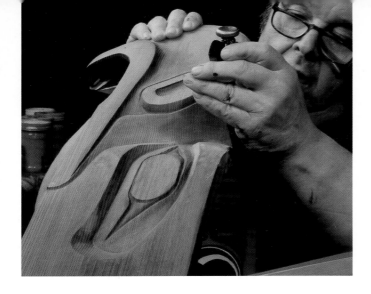

Trim edges so the sides will align when closed.

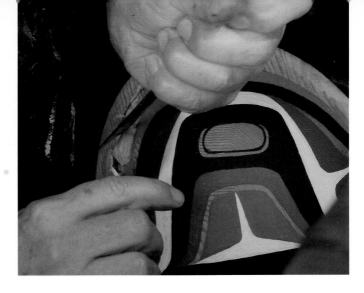

When the glue at the stop has set, clean away the excess and trim to size.

A carved stop glued to the flange of the cap piece keeps the side panels from moving past the center line. Usually a stop on one side of the flange is sufficient.

Carry the line of the beak into the lower jaw. This cannot be done until the mask is assembled.

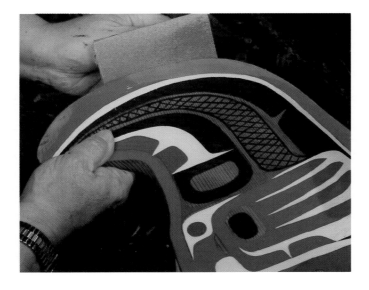

Sand the areas that you adjusted.

The result.

84

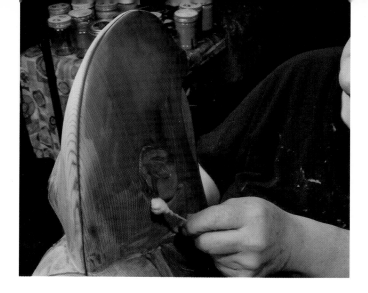

Apply oil to the newly exposed areas. I am using a cotton swab wrapped with a cotton ball for extra absorbancy.

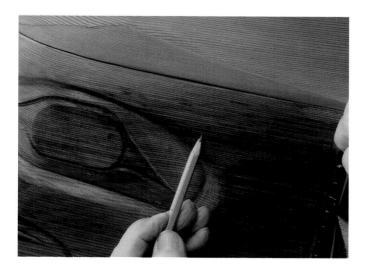

When the oil has dried, draw in the design to be painted on the outer mask. The designs may vary from the ones I have used here, but these may be helpful to you.

Paint the outside of the outer mask. The techniques follow those used on the inner mask.

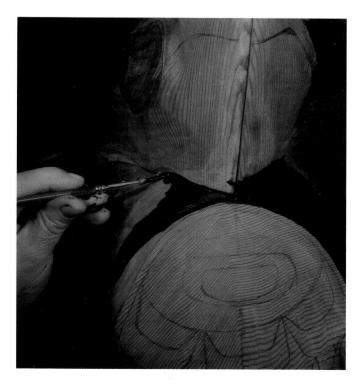

I usually begin with black. Here I am starting at the brow.

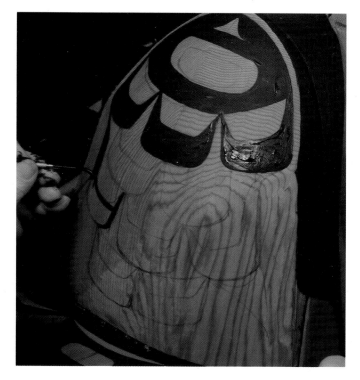

I continue with the feather pattern of the forehead, which reflects the patterns of the inner mask.

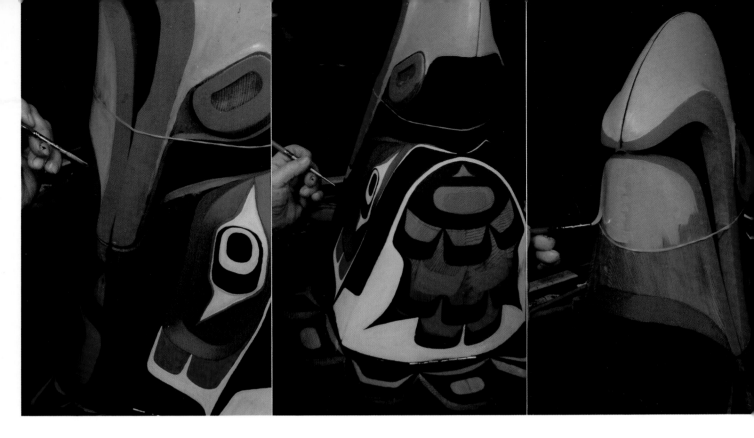

Continue with the other colors.

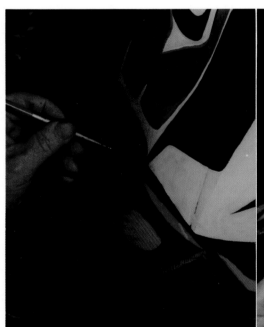

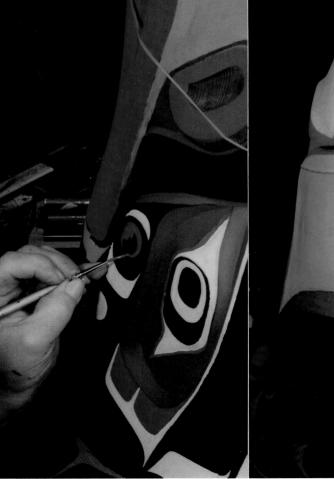

If you want to paint metal, like the hinges, it is best to cover it first with lacquer or nail polish.

Continue with the details and touch up.

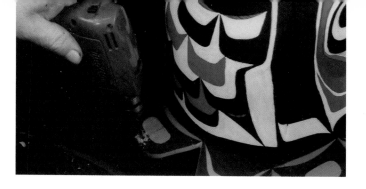

Holes go in the top of the fringe...

and there is one in the top panel about 4" from the back edge.

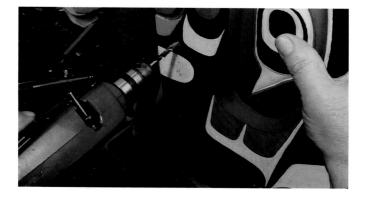

and in lower edges of the side panels about one inch up and about six inches from the back.

Clean the holes with a knife.

In the fringe at the side of the mask drill a hole at about the same height as the hole in the side panel.

A tar impregnated nylon is used for the control ropes. This is the same product used for fishing nets, and has the strength and resistance to fraying that I need. I'll begin the strings with the cap. Tie a tight knot in a piece of cordage about 4 or 5 feet long. It will be trimmed later. Run it through the top panel from the inside.

Another hole goes in the center of the lower jaw, about 5 inches from the back...

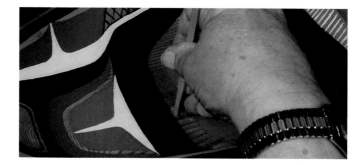

Drive a wedge into the hole to hold the cordage in place. Trim off the excess wedge.

Trim the cordage down to the knot. We could hide the string, but in use they need to be changed often, so we just camouflage them a bit and touch them up with a little paint.

Run the string through the hole in the fringe.

The bottom panel will fall of its own weight, so it needs only a string to pull it up. The knot is beneath and the string runs into the lower jaw...

and through this hole under the lip.

Again wedge the string in place.

The cordage for the side panels is about ten feet long and knotted in the middle. Run the cord through the mask from the outside until the center knot is against the mask.

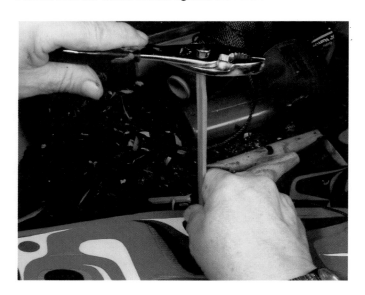

Wedge it in place from the inside.

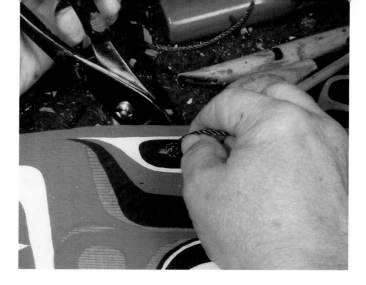

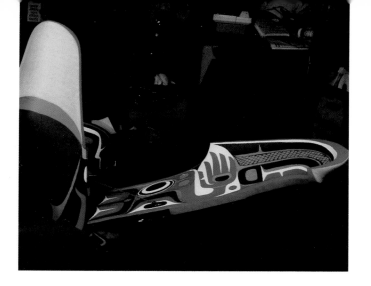

Knot the cord on the inside so the knot is tight against the inside of the side panel.

Repeat on the other side panel.

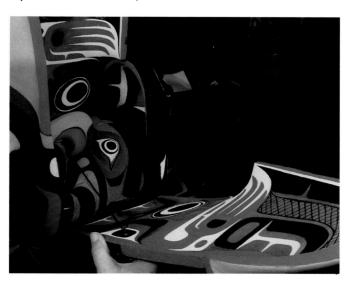

The outside of the cord runs through the hole in the fringe. The other end of the cord will run through the nostril, though it is sometimes necessary to drill an extra hole through the inner mask.

The cords from the side panels are tied together behind the mask to limit the opening. Adjust so the sides open to the same angle. It should not be completely open, stopping at about 30 degrees.

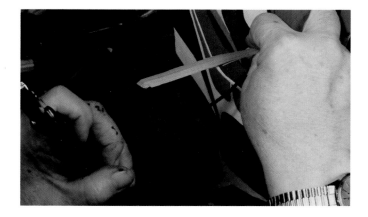

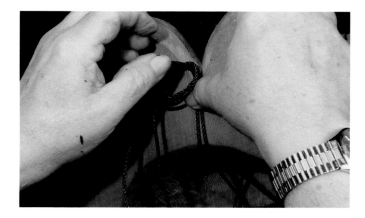

Wedge the cord from the outside as well.

After determining the spot, work a knot from behind so opening of the masks stops at the correct angle. The task is a little cumbersome and you may need to do it more than once to get it right.

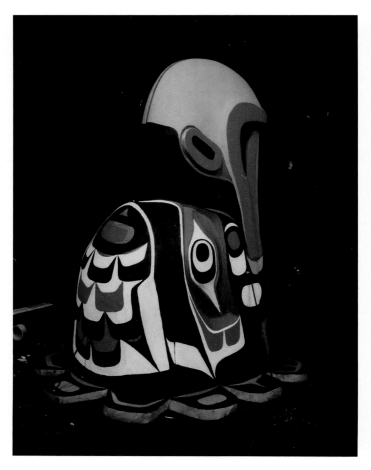

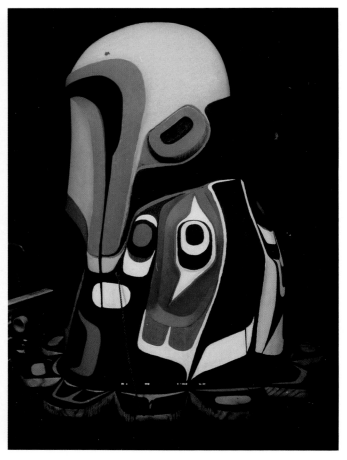

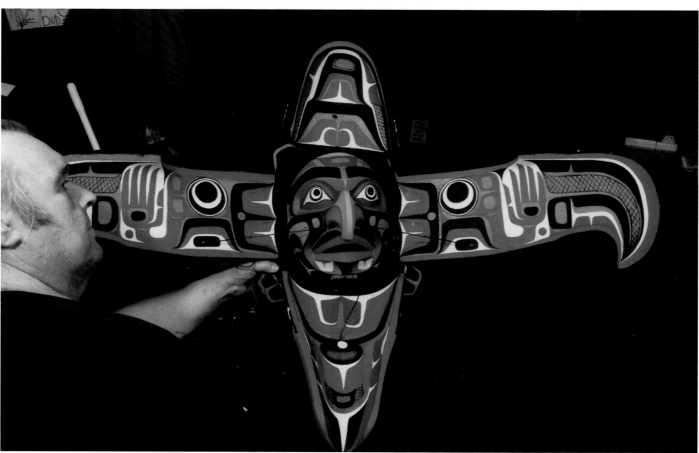

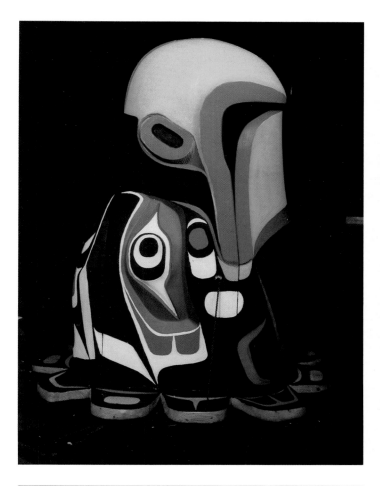

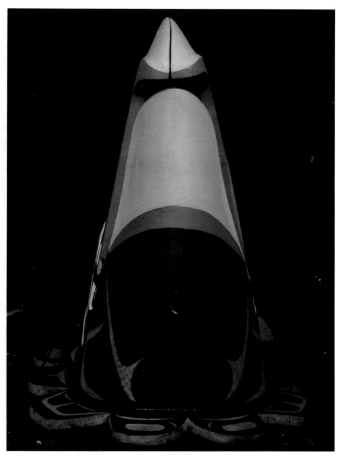

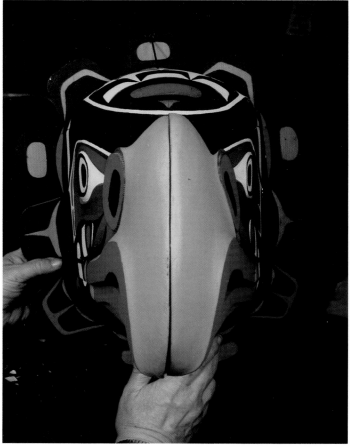

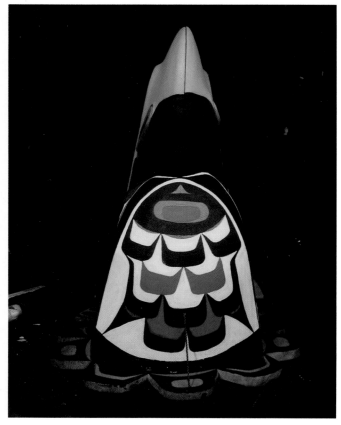

Almost ready for the dance.

WORKING DRAWINGS

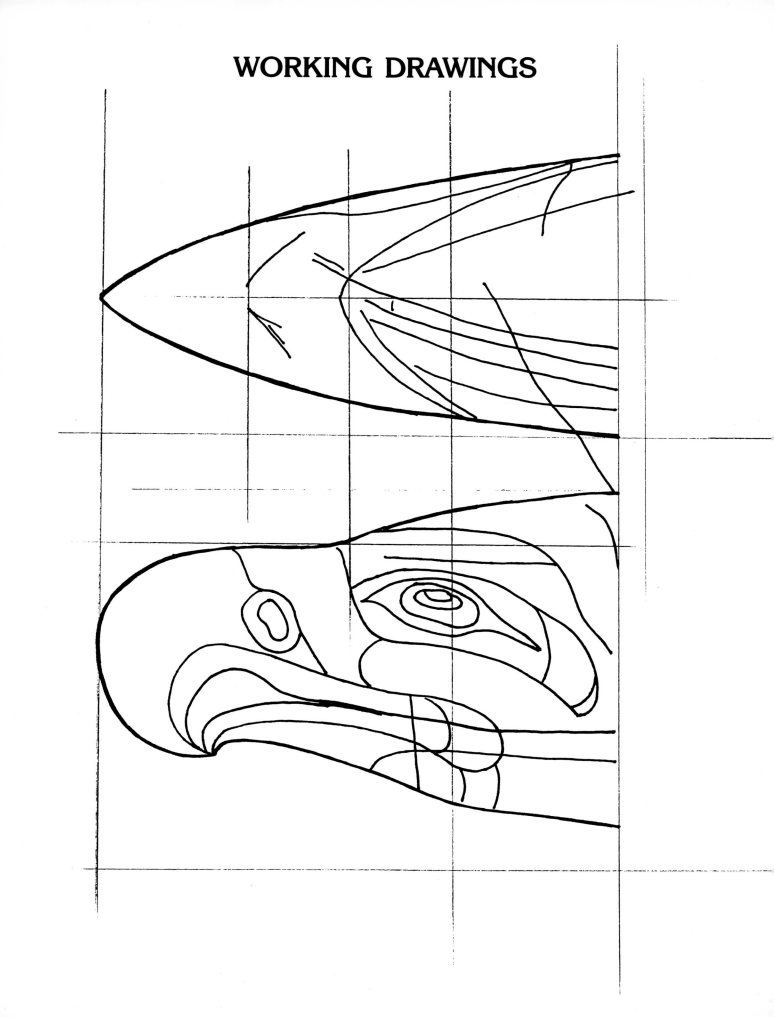

These working drawings are proportional. The overall height of the mask, including the fringe is 24 inches. The outer mask is 28 inches long. To enlarge the drawings to full size, use a photocopier to increase the size 500%. You will probably need to do one section at a time.

Scale: 1" on the drawing = 5-1/8" actual size.

GALLERY

The Project Mask

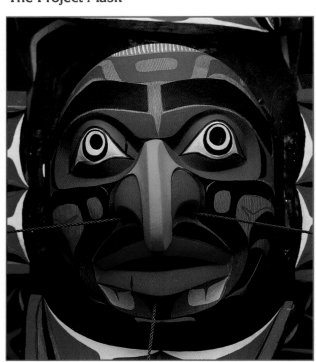

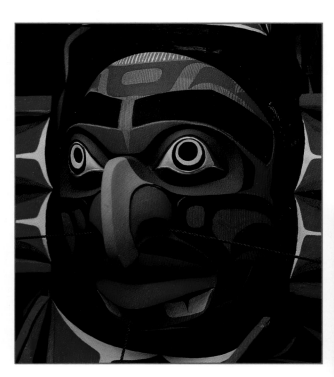

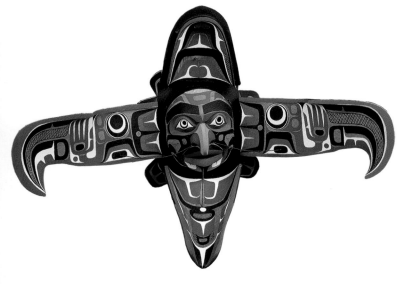

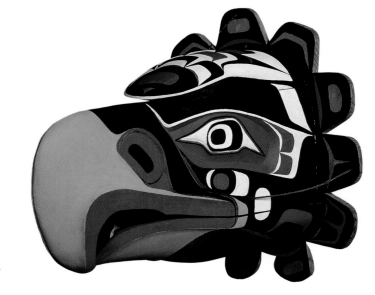

Dzonoquah
Carved by Lelooska

The Dzonoquah, the timber giant. All up and down the northwest coast we hear stories of these big hairy giants who live in the depths of the woods. The Dzonoquah is a very important character in the mythology of the Kwakiutl people and in some cases is considered to be an ancestor. Even today on a long winter's night, when the Kwakiutl children get noisy or fight over the TV, the grandmother or grandfather will warn, "If you're not good the Dzonoquah will come tonight and reach out with his big hairy arms, carry you into the forest and eat you!" At that point things usually get very quiet. The youngsters sort of melt away.

The Dzonoquah is one of the traditional symbols of the chieftaincy and of the warrior traditions, so it has many more applications than just child control. It is associated with the coppers, the great symbols of wealth among the Kwakiutl people. When the chiefs are distributing their coppers they will wear a small black and red mask of the Dzonoquah.

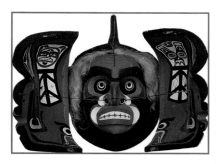
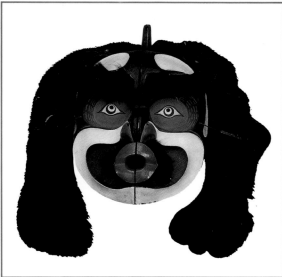
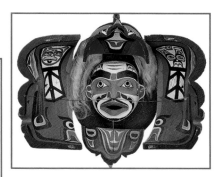

Grandmother
Carved by Lelooska

This is one of my favorite stories. We've put it together from little bits and scraps over a number of years. One elder would remember this part and another would remember another part, and eventually it was all reassembled. It illustrates well the wonderful bond between the elders and the young.

Have you ever wondered why it is our fishermen have no fear of the fog, why they will dare the densest weather to go out and set their nets. The reason is that we have a friend who watches over us. She calls us back from the fog. A long time ago there was a woman. She was a good old woman and she was rich, and she also had supernatural treasure. Two grandchildren had she, a boy and a girl. There came a time in the spring of the year when granny decided to take the children in her small canoe, with her fishing mats and hats and tools. They all journeyed out to sea, to the great rocks. There they gathered kemp, which they would dry in the sun and eat. It was a rare fine day.

The sun was out and sparkled on the water, and the sea birds circled in the sky and they sang.

The children loved to be with old Granny. They revelled in the old songs she sang and the old stories she told. They had such a good time!

But on that fine day there rose up a cold gray wall of fog. In less time than it takes to tell, the little canoe was carried by the sea current deep into that fog bank. Oh, it was dense. They could hardly sea their hands if they held them out before themselves. After a while the children grew restless. They remembered the stories of terrible sea monsters with mouths so huge that, rising up from ocean depths, they could swallow whole canoes. They began to fret and cry, but old Granny soothed them. No sooner this than looming up out of that dreadful fog came a huge dark shape. It swept towards them and passed so close by that the little canoe bobbed in its wake. Oh, it was the sea monster!

Granny knew what it was. She would have preferred the sea monster to that which she knew was coming. It was a great war canoe down

from the north, filled with fierce warriors come south to take heads and slaves among the southern tribes. Granny knew that under the cover of that fog other such things were lurking, silent as sprawling wolves. She told the children to get down in the bottom of the canoe and she covered them with fishing mats and told them to be quiet.

Then the old woman who had counseled silence did a strange thing. She started to sing. In a high clear voice she sang a wild strange song the children had never heard before. They had heard Granny sing many times, but this song sent a shiver down the back just to hear it. Then the little canoe made a little shudder in the water and there was a great flutter of wings. Somehow the children knew that Granny was no longer there. Peeking out from under the fishing mats they saw in the old woman's place the single glossy feather of a loon.

And then it came high and clear, and sharp as a knife, through the fog. The cry of a loon. It called and it called out of the darkness. Its voice strangely familiar. And the children waited and listened and then they took up their paddles and started to follow the sound of the loon through the fog. On and on they went, and when they became unsure they stopped and listened,

and then out of the fog came the gently assuring call of the loon.

They paddled and they paddled listening to the loon, when all of a sudden slender fingers of sunlight began to find their way down through that awful fog. Then they paddled a little more and they found themselves in the clear. Just ahead of them was their own village, with its long low rows of cedar houses. The canoe was brought up onto the shore with the children home and safe. They warned the village of the northern raiders hiding in the fog.

A long, long time before Granny had wandered deep into the rainforest, and there near a deep strange glade she met the loons. She saw them for what they truly were, not mere birds, but supernatural beings filled with power and knowledge. Granny, as young as she was, befriended the loons and they granted her supernatural power. Through the years Granny used that power. Whenever she chose to sing the song, the power would work and she would become a loon. Everyone knows that loons are the only creatures in all of nature that can see through the dense fog. Her loon's eye saw the way to safety. Her loon's voice beckoned the children home. She is out there yet, and she calls to our fishermen...calls them safely home.

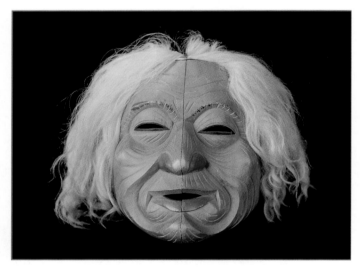

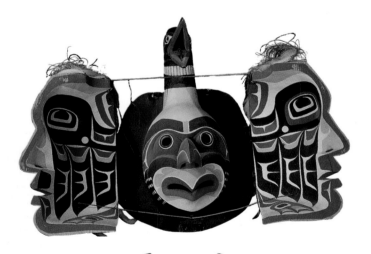

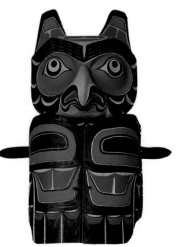

The Owl
Carved by Tsungani

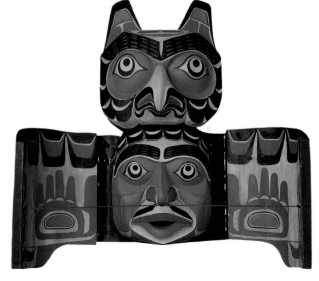

96